# In Paris

# In Paris

20 Women on Life in the City of Light

JEANNE DAMAS
AND LAUREN BASTIDE

PENGUIN BOOKS

PENGUIN BOOKS

An imprint of Penguin Random House LLC
375 Hudson Street
New York, New York 10014
penguinrandomhouse.com

Published simultaneously in Great Britain by Viking, an imprint of
Penguin Random House UK, and in the United States of America
by Penguin Books, an imprint of Penguin Random House LLC, 2018

Originally published in French as *À Paris* by Éditions Grasset et Fasquelle, Paris

Published by special arrangement with Éditions Grasset & Fasquelle in
conjunction with its duly appointed agent, 2 Seas Literary Agency.

ISBN 9780143133681 (hardcover)
ISBN 9780525505471 (ebook)

Printed in China

10  9  8  7  6  5  4  3  2  1

Text design by Francisca Monteiro
based on Matthieu Rocolle's original concept
Set in Plantin MT Pro

To our city,
with love.

# *Contents*

# *Foreword*

The idea for this book first came about in April 2016. We had this dream of travelling all over Paris to meet the city's most inspiring ladies. Ella Fitzgerald and Louis Armstrong sang about April in Paris, and the city was just like the song: there were chestnut trees in blossom, a sparkling River Seine and Parisiennes shivering in their soft, light knitwear, handbags brimming over beneath tables at café Aux Deux Amis on rue Oberkampf. It was a typical spring in Paris. But then again, it was unlike any that had come before. The capital was still in shock. Six months earlier, in November 2015, our city had been devastated by gunshots exploding in places where Parisians dance and celebrate. Many young and carefree lives were destroyed. Parisians had spent the winter doing what they do best: drinking, chatting, loving each other, but with underlying anxiety, often glancing over their shoulders. Everyone grieved in their own way, and Paris began to wake up again, cheerfully; bruised, but proud. You could feel all of that outside café Aux Deux Amis that day.

After our initial meeting, we began our tour of Paris. Between April and December 2016, we roamed the city, but we felt strange. Not sad or bitter. Quite the opposite. Joyful. We wanted to hug people sitting outside bars and restaurants, kiss fellow travellers on the

métro. We've always been crazy in love with this city, but even more so now, after the tragic events of November 2015. We love its arrogance, its clumsiness, its simplicity. And especially the women who live here . . . after all, according to Jack Kerouac, 'Paris is a woman'!

Anyway, let's go back to the table outside the very Parisian café Aux Deux Amis, where we sat smoking cigarettes over a glass of Pouilly-Fumé. Both of us were ridiculously faithful to the Parisienne stereotype, the woman who has mastered the art of creating an outfit from next to nothing: combining ripped jeans with a cashmere sweater, knotting a trench coat over a floaty dress, rolling up the sleeves of her blazer, slipping on worn-out ballet pumps to go dancing. All the characteristics contributing to the allure of the mythical Parisienne have already been largely, sometimes perfectly, depicted. Others before us have explored the Parisienne's charming moodiness, her confidence and her quirks: the way she raises her middle finger at a driver beeping his horn at her refusal to use the zebra crossing and how she ignores a phone call she's been expecting for fifteen months. In short, her indifference.

We often have fun spotting some of the characteristics of this contemporary heroine in ourselves. But we also often say that the Parisienne is not the idealized woman that's sometimes portrayed. She's not just this girl with a great look and crazy intensity. Parisiennes are more than that. Because, as we said to each other that day, we know many kinds of Parisiennes. A Parisienne will create her own start-up in Aubervilliers, raise three children near place de la Bastille, thrust her fist in the air as she protests in place de la République, dance to hip-hop near place d'Italie, collect trinkets in Belleville, open a restaurant on rue de Paradis, direct films near Jardin du Luxembourg. We have never met a single stereotypical Parisienne who lives with her cat on boulevard Saint-Germain and spends the day lounging around on a sofa while browsing a collection of short stories by Simone de Beauvoir. It's not that we want to set the record straight

or even deny the existence of this archetypal Parisienne. The Parisienne exists, and we know she does because we've met her twenty times for this book. But if there's one thing that defines the Parisienne, a common denominator that goes beyond the way she dresses or speaks, it has to be, first and foremost, her approach to living in the city.

This book was born of a desire to go out and meet authentic Parisiennes from different backgrounds and walks of life. We wanted to discover their many different qualities and create an impressionist portrait of the Parisian woman. We had no intention of shattering the aforementioned stereotype, but instead we wanted to bring the myth to life by interviewing twenty women on the way they choose to live in Paris and their relationship with the city.

Jeanne was born and raised in the eleventh *arrondissement,* and still lives there in a top-floor apartment overlooking square Maurice Gardette. She describes herself first and foremost as the daughter of a locally renowned restaurateur who ran the fabulous Le Square Trousseau restaurant. She lugs her shopping basket around Aligre market every Saturday and on Sunday she'll hunt for pre-loved ceramic vases which she'll use to haphazardly display armfuls of wild flowers. I'm Lauren, the one writing these words, and I've just celebrated twelve years in the ninth *arrondissement.* I push a state-of-the-art buggy down rue des Martyrs, buy tons of left-wing papers and magazines at the weekend and eat organic salads in health-food cafés. If there's something that makes us Parisiennes, it's primarily this: the way we construct our daily life in the city. This was the idea that emerged one evening in April at café Aux Deux Amis, and we decided to put it into practice in the most Parisian of ways: by roaming all over the city.

So, notebook in hand and Olympus camera over the shoulder, we set off to meet our Parisiennes. We chose our interviewees intuitively, with no ulterior motive. We stumbled upon one while scrolling

through Instagram, fell in love with another when having a drink one evening in a bar. We consulted friends of friends, mothers of friends, grandmothers of friends, women we admire.

We haven't attempted to create a comprehensive sample group; we're not anthropologists or sociologists. The Parisiennes featured in this book all belong, as we do, to the world of fashion, media, culture and art. At the end of the day, they're just *our* Parisiennes. Those we've been fortunate enough to meet during the nine months it took to research this book.

Each encounter provided new information, including some surprises. Our Parisiennes helped us understand the individual features of women's lives in Paris and inspired much of the additional information on the city that we've included between chapters. Our Parisiennes have challenged many of our beliefs and confirmed a number of our suspicions. They may live in an attic room, on a barge, on the fourteenth floor of a tower block or hidden in a little courtyard. They come from all walks of life, all social backgrounds, all cultures. But one thing unites them all: the confidence they have to be themselves. We chose these specific Parisiennes because they have what Jeanne often describes as a 'little something extra', that could be the 'it' in 'it girl'. Each of them has invited us to take a walk in her shoes. They've shown us that Parisian women are at one with their city. And at the end of our grand tour, we realized that together we had painted a portrait of Paris. Nothing surprising about that. For the only true Parisienne is Paris herself.

Lauren Bastide and Jeanne Damas,
in Paris, 30 May 2017

# Rue de Lappe
## *with* Amélie Pichard

*A kitchen garden*
*Two cats*
*Pamela Anderson*
*A handful of chia seeds*

Most Parisiennes and fashion-lovers know Amélie Pichard. Since she launched her eponymous fashion label in 2010, her brand and identity have taken off. Her candy-pink shearling court shoes helped to establish her reputation, further promoted by the sparkly fringed mules she created with Pamela Anderson and the label's adverts that feature red-headed models roaming countryside lanes. Everything Amélie Pichard creates looks very Amélie Pichard, so we were keen to see her apartment. And one morning in June, we ended up in one of the most typically Parisian *quartiers*, within the labyrinth of cobbled backstreets that frame place de la Bastille. It was all there: the building's half-timbered hallway, the wonky stairwell. We worked our way up the three floors leading to her little hideaway where she greeted us with a cheerful hello, her red hair flowing down to her vintage T-shirt tucked into very skinny 501s. That's Amélie Pichard to a T.

One art in particular is very Parisian: the art of expressing your taste through the way you dress or the way you decorate your apartment. Although it could be said that 'decorating' is a rather poor word to describe the energy many Parisiennes use to turn their home into a cosy, unique little hideaway that they'll struggle to abandon for more than two hours in a row. Amélie is an expert on this. We could

easily paint her portrait without asking her any questions at all, but instead taking a peek into all the nooks and crannies of her apartment. Her living room is filled with objects evoking 1960s America, as she draws much of her inspiration from this era. And taking centre stage on a wall near her front door, there's a really old artificial leg, a reminder of the time when she learnt the art of making shoes from a genuine orthopaedist in the Quartier Ledru-Rollin in the twelfth *arrondissement*.

Amélie Pichard has also mastered the art of effortlessly and warmly welcoming guests into her home, even at ten o'clock in the morning. A few minutes after entering her apartment, there we both are, curled up, barefoot, on her velvet sofa, calves caressed by two large Persian cats that live there half of the time (Amélie and their father have joint custody). The designer rules her world with self-confidence and exuberance, and her world extends to the building's little cobbled courtyard covered in moss. 'I've just created a kitchen garden out there. I've planted tomatoes, aromatic herbs, strawberries. And I'm soon going to set up a compost bin,' she tells us proudly. 'Just ten years ago, there was still a goat and chicken down there.' The maisonette attached to the courtyard had previously been home to a concierge, but then one day it became available. Amélie decided to rent the place and transformed it into a workshop, relieving her little apartment of a considerable number of shoeboxes at the same time. Some months later, she met her boyfriend there. He was a director who'd come to film her business. 'I'm like a bear, I stay in my den, lying low, and things come to me,' she boasts.

If things come to her, that's because Amélie manages to find a way of organizing her life so everything takes place in a confined area close to her home. For example, she has recently opened her first boutique on rue de Lappe, just around the corner. Two years ago, before she laid her hands on the maisonette, one room of her apartment was fitted out as a workshop where she designed the prototypes

for shoes. She still uses the room as an office and creative space. Her next collection is taking shape on inspiration boards where photos of David Lynch and Guy Bourdin as well as portraits of Bettie Page are pinned. Although she trained as a clothes designer, Amélie found her path in life when she realized that she enjoyed creating objects instead, something she thinks is a more 'masculine' penchant. Amélie Pichard decided to swim against the tide of fast fashion, instead coming up with a very Parisian way to be a successful designer.

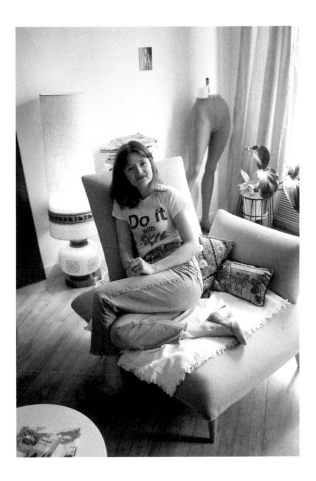

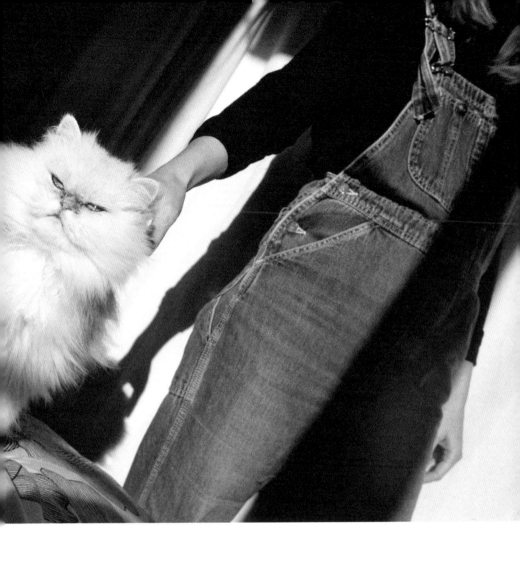

While chain-smoking cigarettes and smiling continuously, she begins telling us about her life. Like the large majority of Parisian women, she didn't grow up in the capital. Her home town is Chartres, a couple of hours from Paris. She spent every Wednesday and school holidays on her father's farm, before he passed away when she was still a little girl. She spent the rest of the time with her mother and younger sister. She hated school and used to draw figures of women in the margins of her exercise books. When she was fourteen, she worshipped French popstar Ophélie Winter and Pamela Anderson, who she would later meet and with whom she would create her famous collection of vegan footwear. Like many of us, she experienced the mad impulses of teenage angst, which in her case drove her to bleach her hair platinum blonde; she then had to cut it really short to appease her mother. 'I started feeling happy when I arrived in Paris at the age of twenty,' she remarks.

When we ask her to reveal a Parisienne's most prized possession, she says it's her address book. Amélie herself never puts a step outside the small and well-defined area that lies between La Bastille, rue de Charonne and boulevard Ledru-Rollin. Within this area, there's her local café where she goes every morning to knock back a black coffee after devouring her breakfast (porridge oats with almond milk, kiwi, banana and chia seeds), her florist, stationer's and newspaper kiosk. 'It's my provincial side coming out,' she says, smiling coyly, when actually there's nothing more typically Parisian than thinking of your *quartier* as a small town in its own right, sighing when you need to walk an extra block because your usual pharmacy is closed, making a point of not buying bread in any other *boulangerie* than the one on your own street corner and being able to name all the shops within the ten streets closest to yours. These are all signs that you're very Parisian.

It could be that Amélie is so attached to her *quartier* because she's primarily a sedentary person, as she says so herself. For her, just

crossing the Seine to go to '*l'autre rive*' (the other bank) feels like an expedition. And what's the point? Parisians (the ones we know at any rate) have the most fun when they're at a friend's place dancing around a turntable or a speaker, taking breaks from time to time to smoke cigarettes and philosophize, eight squeezed on to the balcony. True to her principle of making everyone come to her, Amélie now entertains a lot at home. When she invites guests over, she orders cases and cases of champagne. She brings together friends from all areas of her life, and they all mix very happily. Her soirées have a reputation for being some of the most fun-filled, crazy parties in the whole *quartier*. And, miraculously, her neighbours never complain about the noise, something that's as important for Parisian apartment-hunters as a view over the Seine. So her speakers blast out playlists featuring the Beach Boys, Blondie and Beyoncé until the early hours of the morning.

# Our Paris.
## Village life in the city

The main thing we have in common with all the Parisiennes we've met is that we define ourselves primarily by where we live (our *arrondissement*, *quartier* and apartment).

We believe it's essential to make our home incredibly comfortable, whether we have an opulent apartment or a small attic room. We add candles, cushions, old books and soft sofas to create a place for working, dreaming, procrastinating and entertaining friends on Friday and Saturday evenings, because it's so much better when everyone comes to us. In terms of our *quartier*, and by *quartier* we mean the buildings that surround our home, there needs to be a local café we can pop into in the morning, lean over the counter and get our americano-no-sugar-please without saying a word. Of course, we also have our favourite *boulangerie*, which is never the really busy one that attracts crowds of tourists (queueing is such a pain), but rather the one where a traditional baguette only costs one euro ten cents and the ham, salad and mayonnaise sandwiches are delicious. Here's the living proof that we're at one with our *quartier*. Jeanne is always insisting she would like to move to the ninth *arrondissement*, but she only looks at property adverts in her

**Ten local *boulangeries* and why we love them:**

I. *Terroirs d'Avenir*, for its sourdough loaf (*pain de campagne*) and tomato focaccia. 1 rue du Nil, 75002

II. *Le Moulin de la Vierge*, for its chocolate éclairs. 64 rue Saint-Dominique, 75007

III. *La Boulangerie Verte*, for its croissants and irresistible *chouquettes*. 60 rue des Martyrs, 75009

IV. *Du Pain et des Idées*, for its orange-blossom brioches and lardon bread. 34 rue Yves Toudic, 75010

V. *Julhès Paris*, for its macarons and delicatessen. 56 rue du Faubourg-Saint-Denis, 75010

VI. *Boulangerie Utopie*, for its apple turnovers to die for. 20 rue Jean-Pierre Timbaud, 75011

VII. *Moisan Le Pain au Naturel* in the incredible Aligre market, for its organic, traditionally baked bread. 5 place d'Aligre, 75012

VIII. *Le Blé Sucré*, for its pains au chocolat and mini strawberry cakes. 7 rue Antoine Vollon, 75012

IX. *Boulangerie Boris*, for its mini sandwiches and delicious baguettes. 48 rue Cauaincourt, 75012

X. *Boulangerie Alexine*, for the best custard tart in Paris and its lardon breadsticks which you should eat while still warm. 40 rue Lepic, 75018

**Ten local cafés:**

I. *Le Saint-Gervais*, for good quality food *and* outdoor seating in the Marais district.
96 rue Vieille-du-Temple, 75003

II. *L'Escale*, for a coffee and croissant at the bar while looking out over the Seine.
1 rue des Deux-Ponts, 75004

III. *Le Pick Clops*, for a beer while watching the crowds pass by.
16 rue Vieille-du-Temple, 75004

IV. *Le Rouquet*, for a typical French lunch in the centre of Saint-Germain-des-Prés.
188 bd Saint-Germain, 75007

V. *Le Mansart*, for a glass of rosé on a summer evening in Pigalle.
1 rue Mansart, 75009

VI. *Le Petit Château d'Eau*, for a lazy coffee in the afternoon.
34 rue du Château d'Eau, 75010

VII. *Le Carillon*, for a drink sitting outdoors on the sociable terrace.
18 rue Alibert, 75010

VIII. *Aux Deux Amis*, for a glass of natural wine and outstanding tapas.
45 rue Oberkampf, 75011

IX. *Le Penty*, for Didi who's so upbeat, and her two-euro fresh mint teas.
11 rue de Cotte, 75012

X. *Le Folies*, for a pint on a summer evening surrounded by local Belleville youngsters.
8 rue de Belleville, 75020

current *quartier*. She's well and truly anchored in the eleventh *arrondissement* where she grew up and where she bought a little apartment with her first wage packets. Anyone who follows her on social media has seen her marble fireplace and her cat Charlie, who lounges around on her bookcase. It's hard to tear someone away from a home like that.

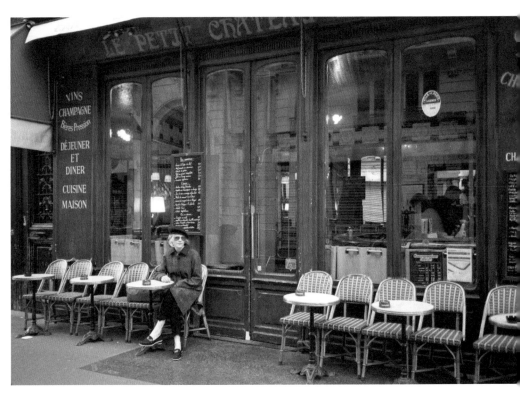

# Le Square Trousseau
## *with* **Nathalie Dumeix**

*A ribbed polo neck*
*Scrambled eggs and sautéed potatoes*
*Small wooden clogs*
*Guy Bourdin*

From the moment we started compiling a list of Parisiennes to feature in this book, Nathalie was at the top of Jeanne's list. Nathalie is a stylist who created her own brand and for the last twenty years has been selling her designs in a boutique near Le Square Trousseau, the restaurant that Jeanne's parents used to run. In her boutique, she sells the Parisienne's perfect wardrobe, the kind that's always described in foreign magazines seeking to capture the quintessential style of the woman they say lives in a trench coat from January through to December. In the shop, you'll find a mix of high-waisted trousers in fine corduroy fabric, ribbed polo necks, ultra-delicate gold jewellery and wedge sandals. In short, the comfortable, chic costume of the Parisienne. Jeanne very much fits that bill. Indeed, it's partly thanks to Nathalie's boutique that Jeanne discovered fashion; as a teenager, she would pop in after school to talk about clothes and boys.

We meet up with Nathalie at Le Square Trousseau in the twelfth *arrondissement*, not far from place de la Bastille. We sit outside. The blue sky is shaded by fluffy white clouds. Everything about Nathalie's appearance screams Paris: she's wearing a trench coat, obviously, and her seemingly unstyled flaxen blonde hair tumbles down over her shoulders. She wears very little make-up, and her face appears

to have become more beautiful with time, which seems to pass her by without leaving a trace upon her flawless skin. She's extremely slim despite ordering scrambled eggs, ham and sautéed potatoes at around 11.55 a.m. Let's face it, when you meet Nathalie, you want her to reveal all her secrets. That's the kind of woman she is. She makes you want to dress like her, smile, speak and age like her. Exactly how the whole world feels about Parisiennes.

She got her incredible sense of style from her mother, who dressed her as a child 'in cute duffel coats and little wooden clogs she ordered from Sweden'. She didn't grow up in Paris, but in Châtillon-sur-Seine, Burgundy, where the river flows that would bind her like a thread to the capital. Nathalie was sure of her destiny. When you decide to 'go up to Paris', you need to be completely sure that there

is, in the labyrinth of *arrondissements*, something that awaits you, or rather, something to go and seek out. Indeed, most people move to Paris to achieve a professional dream, although sometimes it's for love, of course. Personally, I arrived here at the ripe old age of twenty-three, motivated by a desire to become a journalist. Where else other than Paris can you become the next Françoise Giroud? When Nathalie was nine, she wanted to be 'Coco Chanel or Marie Curie'. In fact, she has the unfailing elegance of one and the rather serious demeanour of the other. Her destiny could only have unfolded here.

For Nathalie, the city is like a vast patchwork quilt embroidered with fragments of her life. She arrived in Paris when she was seventeen. She studied at the famous ESMOD fashion school, which has seen many generations of designers pass through its doors and continues to train future talent. She spent her evenings at nightclubs such as Le Palace and Les Bains Douches. It was the 1980s, and anyone who was anyone in fashion and showbiz frequented these night-time haunts. It was at this time that she met the photographer Guy Bourdin and designers Dorothée Bis and Pierre d'Alby (who were the equivalent of today's Phoebe Philo and Raf Simons). She also met the 'Caca's Club' set that came out of Sciences Po university, and who mixed reading and drinking in a way that was possible only in Paris. 'I'm an insomniac, I need very few hours' sleep. So, I've always been the perfect night-time companion. I've never drunk alcohol, other than a glass or two, and I've never taken any drugs. I can have a whale of a time without them.' Now we've put our finger on Nathalie's secret, which is also perhaps the most envied quality in Parisiennes: balance. Not a balance composed of moderation and constraint, but rather a particular way of reconciling the crazy times with the sensible ones, extravagance with simplicity.

Let's take her idol, for example. Without hesitation, she says, 'Françoise Sagan, for her flamboyant side,' before adding, 'and for her melancholy.' A paradox that's typical of Paris. And then there are

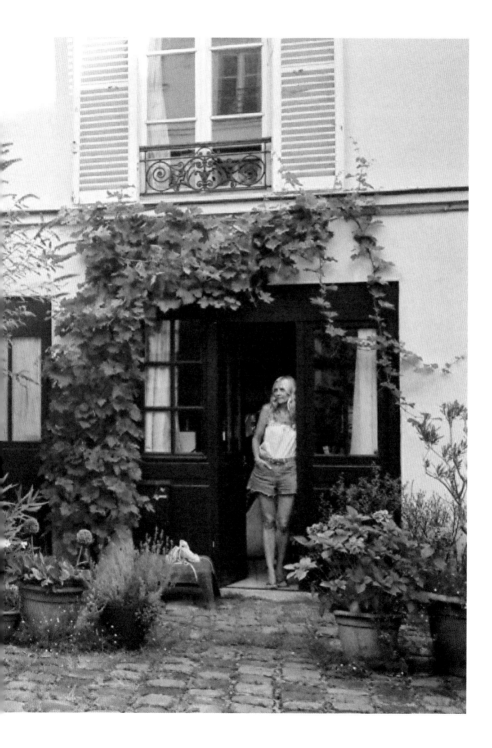

her beauty secrets: she casually assures us that she does next to nothing to maintain her fresh-looking skin and high cheekbones ('I wash my face with warm water every day and apply the latest day cream I've read about in *ELLE*'), but goes on to tell us in meticulous detail about her morning ritual for perfect 'nude-looking skin' ('L'Oréal's CC Cream as a primer, then & Other Stories concealer to hide any imperfections under my eyes and soften the hollows in my face. Then I use a small amount of pearly white MAC powder to sculpt the contours of my face, applying it to the projecting arches of my eyebrows, cheekbones and cupid's bow. Finally, I add a subtle smear of white pencil under my eyebrows'). How about another example? Well, her relationship with food can be completely uninhibited. After devouring her eggs and potatoes, she tackles the mini meringues recommended by the waiter at Le Square Trousseau. And yet, she abides by a few strict rules: no coffee, no tea, no milk products, no gluten. This also applies to her sporting activities: 'I don't do any sport,' she says, blushing. Then she admits, 'I like to walk to Pont-Neuf and watch passers-by, people sitting outside bars and restaurants, historical landmarks.' It must be a good fifty minutes' walk from the twelfth *arrondissement* to Pont-Neuf. Her own kind of sport. Nathalie only ever walks or cycles, and like many Parisians, she easily reaches the magic 12,000 steps a day, which explains both her slender figure and the fact that she has no need to sweat it out on an exercise bike three times a week. Today's lesson on Paris could almost be a philosophical one, delivered by Nathalie outside Le Square Trousseau as the sun makes its way through the grey clouds. Finding a middle ground? No thank you! It's so much better when 'too much' and 'too little' sit side by side, along with energy and lethargy, excess and abstinence. That way we can enjoy more, savour more, live more.

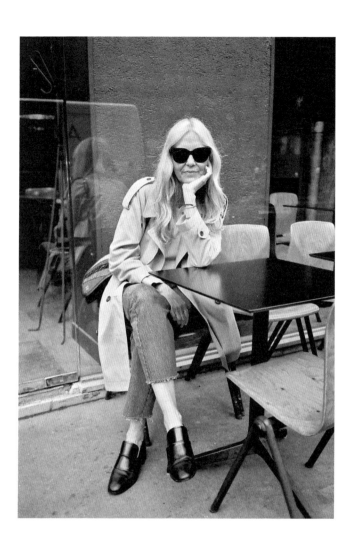

# Our Paris.
## The anti-selfie set

In theory, Parisiennes never take selfies. Waving a camera in front of your face, looking for the right angle, the right light, smiling foolishly at the camera, and then doing that over and over again, and in public? Selfies? They're forbidden. Then again, that's just in theory.

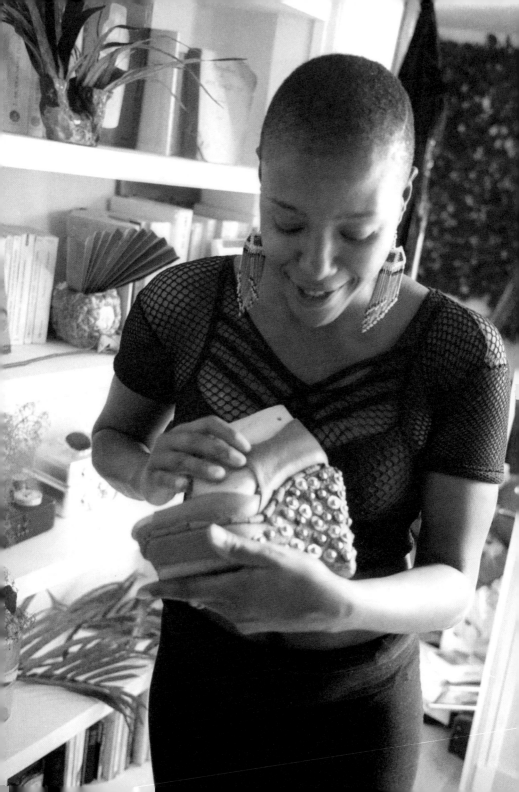

# In the Quartier Chinois
## with **Patricia Badin**

*An apartment under the eaves*
*Beads*
*A shaman*
*Bissap juice*

There have always been these tiny exhilarating nightspots in Paris which have doorways that are hard to squeeze through, where night owls like to huddle together, drinking too much and discussing anything and everything and, once their minds and bodies have warmed up, maybe dance. There's been Le Palace, Le Pulp, Le Baron, Le Montana and, more recently, La Mano, a small nightclub with Mexican décor in the ninth *arrondissement*. When we were writing this book, there were long queues stretched outside La Mano until about one in the morning. Jeanne and I prefer to go there at around 11 p.m., and always on a Thursday to avoid the weekend crowds. We love the rhythmic music, salsa, rumba and Cuban jazz that flows from its speakers, just as much as we love its mezcal cocktails and friendly atmosphere.

These nightspots look like the people who create them, and the person who makes La Mano so warm and welcoming is called Patricia. She was hired to infuse the club with her incredible sense of fun, her beaded bras and raucous laugh. La Mano *is* Patricia, above and beyond anything or anyone else. She's in charge of the venue's communications and PR, and greets people as they arrive. But above all, she performs a hypnotizing samba for hours on the trot, which

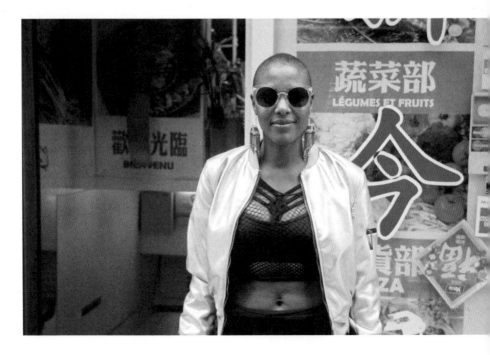

finishes at the end of the night with her getting all the partygoers involved too, by making you want to move like she does, to sweat like she does, and lose yourself in the rhythms. Her charm and charisma echo stars such as Mata Hari, Grace Jones or the French music-hall dancer Mistinguett, who all cleverly combined seduction, provocation and mystery, and contributed to the history of Paris. Patricia is an archetypal heroine of night-time Paris.

Jeanne and I meet up one morning outside Patricia's place in the fourth *arrondissement* and pop into a small, trendy café (Bob's Juice) where green smoothies and lattes are presented artistically. Jeanne went to bed late the night before and turns up with a raging hangover. We have to climb a lot of steps to get to Patricia's. She lives at the very top of a narrow, quirky building in Haut Marais, in a former maid's quarters. Through the ox-eye window of her lounge, you can see the slate rooftops and Gitanes-blue sky. Patricia has also just got up. She danced all night. She looks like a teenager with her shaved head, no make-up and her tight black cotton ensemble. She offers us a seat on a couch covered in cushions and antique fabrics. She immediately gets to work in her kitchenette, making a bissap drink to cure Jeanne's headache. 'I've told myself twenty times over that I should move, find somewhere bigger, but this is my little refuge, I'm good here.' Her apartment is exquisitely and surprisingly decorated; all the little nooks and crannies are home to unique objects, the majority of which are made to be worn. These include beaded headdresses that she's hunted down in Barbès or sex shops in Pigalle, fishnet bodysuits and denim shorts she's adorned with beads from an old kitchen curtain she found on her landing.

Flagrancy and freedom float through her home like a light breeze. Her motto is never to apologize and to do everything, embrace everything. She works at night so she has the freedom during the day to do things for herself and develop her own personal projects. Indeed, she's just set up an organization called 'B'Attitude' so she can

pass on everything that excites her to others: dance, mixology, styling, feminism, natural cosmetics and art. And if there's one thing she knows, it's the art of being herself, and constantly reinventing herself. An art that provides lessons from a whole life spent in the City of Light. 'I've done every single Parisian *quartier*, I've lived everywhere except in the sixteenth *arrondissement*. As far as I'm concerned, Paris is freedom. I've never wanted to leave this city, because you can be who you want here and do what you want here.'

Patricia grew up in the seventh *arrondissement*, not far from the legendary rue de Verneuil, home to Serge Gainsbourg, whose house she used to walk past every morning. 'He used to wave to me and my

sister on our way to school. We were the only black children in the *quartier*.' Patricia was fourteen when she started appreciating Paris by night and found out she felt good here. Free. 'I sneaked out. I told my mother that I was babysitting, but I would spend the night at Folies Pigalle.' When she was seventeen, her mother decided to move back to Guadeloupe, but Patricia refused to go with her. 'I had begun a relationship with Paris. I couldn't see myself living elsewhere, I felt at home and wanted that to last.' There she was, alone in the city that ended up guiding her into adulthood and shaping the happy woman she is today. She tells us about the afternoons she spent in Les Halles, dancing in the square on rue des Innocents, amongst the amateur

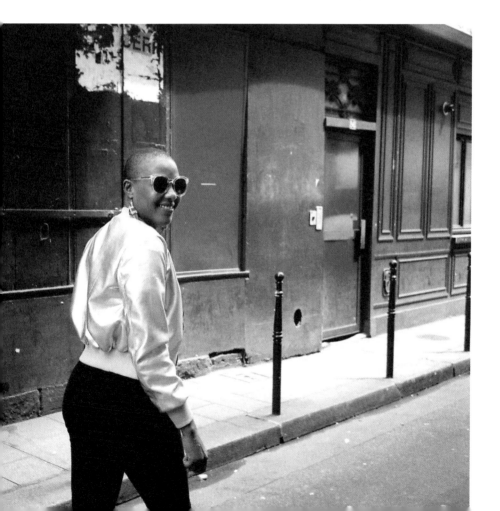

skateboarders and rappers. 'We were a group of girls set on conquering the nightclubs one by one: Le Palace, Les Bains Douches. We were adorable but skint: we would dance all night and they would give us an orange juice in return.' She went on to study Japanese at university, met the father of her son that January, married him in July, and in March the following year, Oscar was born. Her son, now sixteen, lives in square Maurice Gardette, just opposite Jeanne.

When you've grown up in this city with the Tuileries Garden as your playground, along with its view down the Champs-Élysées, you see things on a grand scale. At least Patricia does. And as such, Paris is not enough for her, so she frequently travels far away to satisfy her need for more. In fact, she's just returned from a long trip to Brazil. While sipping bissap juice, she tells us about her travels up and down Brazil, getting together with dancers from the Ballet Funk, their mad dance on Praia Grande beach and the saga of going to see a shaman in a charitable centre on the outskirts of Brasilia. She'd left Paris with her usual basic backpack containing two cotton jumpsuits, a pair of shorts and an embellished jacket so she'd have an 'outfit to dance in'.

Patricia has a knack of creating an outfit from nothing. She can craft a costume to perform in by picking up whatever she needs from shops in Pigalle or vintage clothes stores in Barbès. The clothes, headdresses and shoes that adorn her apartment are little pieces of Patricia. She makes them, but she also is them. They tell the story of her journey, her talent, and the character she becomes each evening when she hits the dance floor at La Mano, encouraging the partygoers to join her and dance.

# Our Paris.
## Going for an *apéritif*

Forget sport, embroidery, gardening and even cooking; for a Parisienne, the most important skill to have is the ability to choose wine. It's a matter of pride. In a restaurant, we know how to grab the menu and bark a firm order at the sommelier before swirling the wine around in our glass with a look of considered concentration on our face. And we do this even with a simple bottle of rosé we're intending to share with friends on a summer evening outside a bar. Wine is a way of life in Paris. Some people prefer reds or whites, Bourgognes or Bordeaux. Both of us like reds; Jeanne is really into Bordeaux, she likes them full-bodied. I prefer Bourgognes, although I'd give anything for a Côte-Rôtie. We like surprises, but not when it comes to vino.

**Our five favourite Parisian wine merchants:**

I. *Cave Augé*, one of the oldest in the capital.
116 bd Haussmann, 75008

II. *La Cave de l'Insolite*, for natural wines.
30 rue de la Folie Méricourt, 75011

III. *Lavinia*, for natural vintages from across the world.
3 bd de la Madeleine, 75001

IV. *Le Verre Volé*, the very first place to be named a '*cave à manger*' (special wine bar and eatery).
67 rue de Lancry, 75010

V. *Le Baron Rouge*, where you can buy wine straight from the barrel if you bring an empty bottle.
1 rue Théophile Roussel, 75012

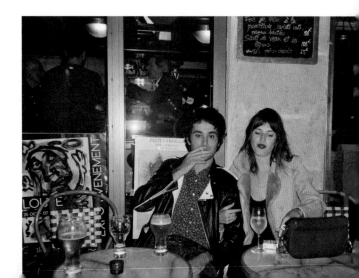

**Five wines you need to order to show you're a connoisseur:**

I. A red *apéritif*: a Morgon from Marcel and Matthieu Lapierre, light and fruity, and you can drink it (almost) as easily as water.

II. A red for dinner: a Philippe Pacalet Bourgogne, a delicate Pinot Noir with character.

III. A red to accompany meat dishes: a Châteauneuf-du-Pape from Domaine de la Vieille Julienne. It smells of the land and the South of France. Or a Saint-Émilion from Michel Favard.

IV. A rosé *apéritif*: a Bandol from Domaine Ray-Jane, to have with ice.

V. A white to accompany seafood dishes: a Riesling from Domaine Binner. A dry, fruity, mineral wine from the Alsace region. It also goes very well with cheese.

# In Village Popincourt
## with **Charlotte Morel**

*A rickety door*
*Tartan*
*A hypnotist*
*Three friends*

How does a thirty-year-old single Parisienne talk about herself? Through her love life, of course. It's mad how quickly we end up talking about love with Charlotte while sitting cross-legged on the armchairs in her cute apartment, despite the fact that we don't actually know Charlotte. Jeanne fell in love with her look (which could be described as both refined and bohemian) on a Saturday morning at café Aux Deux Amis, which is Charlotte's, Jeanne's and now this book's HQ. They arranged to meet up a few days later in Charlotte's one-bedroom apartment by Popincourt market, where the cluster of second-hand shops and local bars have just officially been named 'Village Popincourt'. Charlotte's apartment is even more Parisian than her super-chic appearance. It has a bewitching aroma (almost everywhere you look there are terracotta pomegranates soaked in pomegranate essence from the Italian perfumer Santa Maria Novella). Everything here is sophisticated: the large, bright, white bedroom, the black marble fireplace, the cornicing, the works of art mixed with somewhat kitsch second-hand purchases, even the large crack in the wall and rickety door. 'The building is falling apart, but the area is so popular that one day I will definitely be able to sell it for a good price!' she exclaims, bringing in a tray of steaming green

tea and gluten-free cookies. She says she can't stand being photo-graphed, but moves with incredible ease in front of Jeanne's camera. There is something very calm and self-assured about the way she folds her legs beneath her to sit on the charcoal grey sofa, grips her 1970s ceramic mug with both hands and slides her feet underneath a tartan throw – something very Parisian about it, too. All in all, this young woman is very Parisian. When she asks if we would mind her smoking a cigarette, we lap it up, hanging on to her every word. And that's just the start.

Charlotte grew up in the capital and spent her childhood in a very distinctive *quartier* nicknamed 'the countryside in Paris', found on higher ground in the twentieth *arrondissement* by a stretch of the boulevards des Maréchaux. She went to school at the well-known Lycée Massillon, an unbelievable building and former hotel located on the banks of the Seine. These days the eleventh *arrondissement* is her home, her village, and even the idea of moving sends her into a serious panic. Of course, after a quarter of an hour, Jeanne and Char-lotte realize they have lots of mutual acquaintances.

Straight off, Charlotte tells us that her love life is like something out of a François Truffaut film. And she's right. She was in love with a guy and gives us all the details of their relationship, making us swear, there and then, not to write anything about it in the book. She tried everything to forget him, even going to see a hypnotist 'recom-mended by my gynaecologist who is consequently also my shrink'. She sighs, lights another cigarette and adds, in a slightly theatrical way, 'and then, obviously, I want children'.

She feels most Parisian when she's travelling home in a taxi after a night out and her head is full of music, her eyes soaking up the land-scape of her city as it parades past the open window. 'That's when I realize how lucky I am.' She is madly in love with Paris. Oddly, she also loves Christian Milovanoff's 1980s 'bureaux' photography, washing her hair every day and letting it dry naturally, and Avène

products (a common brand of beauty products sold in all French chemists). But she admits she doesn't care much for make-up or lingerie. 'Having lived in New York for a few months and travelled frequently to Tokyo, I can appreciate the level of freedom women have in Paris. A Parisienne can go out without styling her hair, without a manicure, sit without crossing her legs. Our laid-back attitude doesn't exist anywhere else!'

That attitude defines her and also dominates her daily way of life. 'I've never planned anything, I never put anything in my calendar,' she assures us. True to her generation, Charlotte holds down two jobs, working part-time in a communications agency to pay the bills

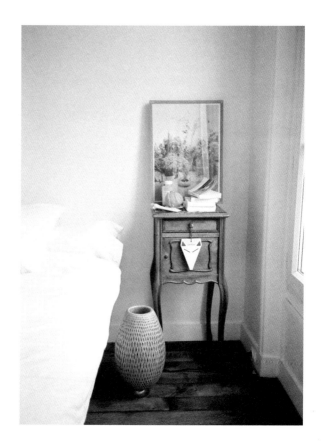

and then running her own business with two female friends she met when studying art history. Their company, which promotes works of art, is called 'We Do Not Work Alone'. In the morning, after a glass of orange juice, black coffee and *tartines*, she starts conversing with her partners via text, and that only really ends when they meet up, often for lunch.

In the afternoon, they work on projects in her friend and colleague Louise's apartment at the very top of a 1960s building on boulevard Richard-Lenoir. 'We're like a big family, we're both godmothers to Louise's daughter, and the large majority of the artists we publish are friends. In fact, more often than not our working day ends with a drink!' That's Paris for you.

# Our Paris.
## Loving the Internet, loathing the Internet

**Ten things a Parisienne never posts on Instagram:**

I. Her cat
II. Her books
III. Her guy
IV. Her kids
V. Her girl
VI. Postcards of Paris by day
VII. Postcards of Paris by night
VIII Her shopping basket
IX. What she's eating
X. Photos of Jane Birkin

**Ten things a Parisienne
posts on Instagram:**

I.    Her cat
II.   Her books
III.  Her guy
IV.   Her kids
V.    Her girl
VI.   Postcards of Paris by day
VII.  Postcards of Paris by night
VIII  Her shopping basket
IX.   What she's eating
X.    Photos of Jane Birkin

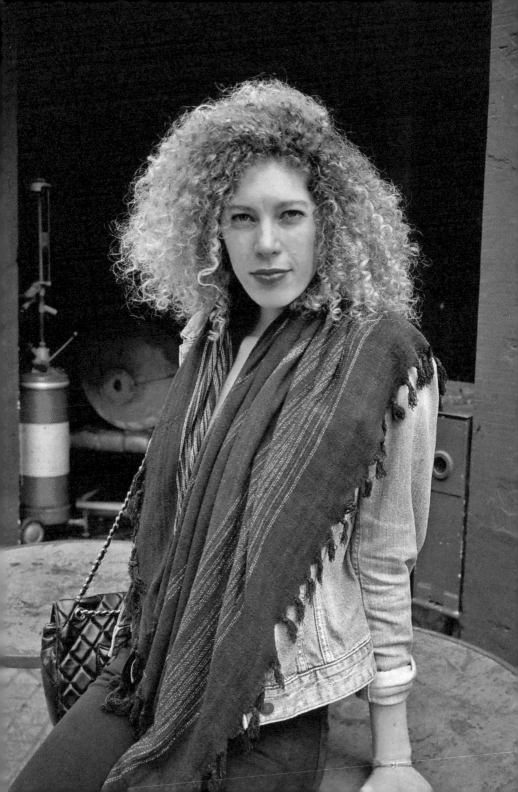

# In Saint-Ouen
## *with* Fanny Clairville

*Saint-Ouen flea market*
*Fine lingerie*
*Top Baccalauréat results*
*Garlic and chives*

These days, it would be mad to say you knew Paris if you'd never crossed the *boulevard périphérique*, the Paris ring road. Like a wall separating Paris from its suburbs, the *boulevard périphérique* is a stark reminder of the social segregation that exists between the city centre and its outskirts. However, our Sunday walks have taken us to locations such as a workshop in Montreuil, a studio apartment in Saint-Denis and a small apartment nestled in a beautiful brick building in Saint-Ouen. Fanny lives in one of these buildings. She adores her pretty one-bedroom apartment that's just a few metres away from the famous flea market at porte de Clignancourt, an essential weekend hotspot for anyone in Paris who loves vintage shopping.

Fanny, a tall, slender woman with beautiful curls, always planned to use her savings to buy an apartment here before she turned thirty. And after years of working to get to that position, she finally did it, barely a month ago. Every item adorning her new home, from the candy-pink fridge to the white roses on the table, has been carefully chosen with this long-held dream in mind.

Fanny manages the Stone Paris jeweller's on rue des Saints-Pères, just a short walk away from the head office of our French publishing house. Jeanne regularly shops at Stone Paris to satisfy her

addiction to the delicate earrings that made the label so successful. Initially, it was Fanny's unique look that made us want to feature her in this book. We didn't expect to hear the tale of a twenty-first-century Balzac-style heroine, the story of a young woman who was born in the provinces and was motivated from childhood by a relentless desire to conquer the capital.

Fanny was born in Bordeaux to a local mother and a Guadeloupian father. Her childhood was spent either in Guadeloupe, on the island of Saint Martin, or at a boarding school in Normandy. When she was still very young, her mother, who worked in the music industry, moved to the thirteenth *arrondissement* in Paris. Like each of the Parisiennes we've met, Fanny speaks about discovering the capital with real clarity and emotion. 'I was thirteen years old, I was in boarding school, and at the weekend I would go to my mother's place in Paris,' she remembers, lighting a cigarette and pouring a second round of guava juice into her pretty wine glasses. 'I was often alone. I would go and get some pho soup on avenue de Choisy, watch films at the MK2 Bibliothèque and do my shopping at Tang Frères because they sold West Indian products there. I remember taking so much pleasure in these strolls around Paris. Actually, I often go back to that *quartier* so I can feel like a teenager again.'

Was it her experience back then that sparked her desire to live in Paris? 'I realized straight away that this city was a sort of rallying point, a place that brought together all the different cultures that nurtured my childhood. Everything is mixed together here.' If she hadn't held on to her dream of living in Paris, perhaps she wouldn't have registered for a competition with Elite model management at a shopping centre in Guadeloupe one summer when she was fifteen. She was really shocked when she won the jury prize. She took a year's break from studying, but soon realized that things were going to be a bit more complicated than she'd expected. 'At the time, very few black or mixed-race women had successfully made a name for

themselves in the modelling world. My agency constantly wanted my hair to be straightened. And I did a lot of showrooms and catwalks in underwear because they thought I had a "body for lingerie". On my travels, I came across girls from Eastern Europe who didn't even have three euros to buy something to eat. They had a determination to make it in the industry that I didn't have. Basically, I soon realized that I wasn't going to be the next Naomi Campbell.' So, the model pupil gained a business degree, did a string of jobs in the poshest boutiques on avenue Montaigne in Paris and Monaco, amongst other places, and ended up landing her current job at Stone in 2013 after a successful encounter with Marie Poniatowski, the brand's founder. Fanny saw an opportunity to 'settle down' in this job, and to take up activities she enjoys again. She loves singing in particular, and has hours of lessons every month.

What Fanny likes best is when her small group of friends come and visit. She holds the foolproof key to making them take the métro to the end of line four: she continually stocks her kitchen cupboards with 'garlic, chives, tomatoes, lemons and basmati rice. So I'm never caught off guard, and I can just add a handful of scallops or a fillet of fish to the ingredients.' So, her friends always know there'll be a delicious dish simmering on the stove. 'It's been a month since I moved here, but the local grocer already knows me really well. I often go down there to ask for products that are hard to find!' These words could only come from the mouth of a staunch Parisienne!

# Our Paris.
## Doing it like a Parisienne

It doesn't matter where you were born: once you end up in Paris, the city will turn you into a true Parisienne. Paris is a global city, enriched by the men and women who come from all over the world to make it their home. Ultimately, what unites everyone who lives in the capital is a particular kind of lifestyle – our Parisian quirks.

I. Squeezing through the turnstile with someone else when you don't have a métro ticket.

II. Hiring a Vélib' bicycle on avenue Trudaine in the ninth *arrondissement* and dropping it off at Palais de Tokyo in the sixteenth. A thirty-two-minute ride.

III. Eating half a baguette on the way home while it's still warm, because that's one stereotype that's true.

IV. Meeting at the bar for 'just-one-drink-I've-got-loads-on-tomorrow' at 7.30 p.m. and emerging at 2 a.m., six bottles of Sancerre later.

V. Buying a pink Bourjois blusher from Monoprix (€12.99) and using it daily for six years after you made the investment.

VI. Talking about food when you're eating (only moving on to politics and sex once coffee has been served).

VII. Planning to reread everything by Marguerite Yourcenar and instead spending Sunday watching Netflix.

VIII. Watching fashion shows and then going to vintage clothes shops to find 'exactly the same thing' you saw on the catwalk.

IX. Buying all the day's papers and magazines, then sitting outside and only reading the horoscopes in *Le Parisien*.

X. Complaining when it's warm, complaining when it rains, complaining when it snows, complaining . . . you know what I mean.

XI. Listening to *Radio Nostalgie* on the old kitchen radio when you have twenty-five brilliant playlists on your computer.

XII. Thinking that arriving fifteen minutes late is being on time.

XIII. Buying organic vegetables at the market then eating a croque-monsieur at the local brasserie for lunch.

XIV. Having a picnic at the park as soon as the temperature hits 18°C.

XV. Buying vintage shoes that are too small and only wearing them once.

# By the Jardin des Tuileries
## *with* **Sophie Fontanel**

*A row of rooms*
*Roasted rice tea*
*Coffee with Chantilly cream*
*Letting your hair go white*

There are six large windows and six little balconies beneath the zinc-covered roofs on the sixth floor, and looking out beyond the pale-blue curtains gently moving in the soft June breeze, you can see the lush, green gardens of the Palais des Tuileries, the big wheel and a cheerful, brazen Paris. Those who follow Sophie Fontanel on Instagram (when we were writing this book, there were 100,000 of them) know this incredible view inside out. Every day, Sophie shares elegant and humorous images and thoughts with the social network, and she admits she's rather addicted to it. She has a dazzling way with words and a unique approach to wearing 'beautiful clothes', but it's mainly her inimitably Parisian way of living her life that appeals to her admirers. And that's why we're visiting her today.

'There's a type of woman who only exists in Paris,' she says. 'There's something ambiguous and contradictory about her. She's a woman who doesn't put on make-up but looks you straight in the eye as if she's wearing mascara. She has diabolical discussions about sex, but is unbelievably prudish in bed. She wolfs down an enormous sandwich but then doesn't eat anything till the next day. Being a Parisienne is a bit like not giving a shit.' Sophie clearly lives her own life according to this philosophy. She wrote a book about a violent

and traumatizing sexual experience she'd had. *L'Envie*, translated into English as *The Art of Sleeping Alone*, is a story of abstinence and has sold by the bucketload in places as far away as America.

Sophie used to write for *Elle* magazine and was also fashion director for the same publication. She now uses her Instagram feed and weekly column for *L'Obs* to pass verdict on the fashion world in a way that no one else would get away with. Sophie finds it impossible to hide her opinion or hold back the urge to say something witty. 'And she always, always, has complete freedom of expression,' stresses Sophie, putting the finishing touches to her summary of the typical Parisienne. 'For example, I don't set an alarm clock for the morning and I spend a large proportion of my time on my bed, but that doesn't mean I'm not working. In fact, being chilled out is a very typical Parisienne trait.'

Taking a chilled approach to life may seem more typical of a Hossegor surfer from the South of France, but actually Sophie's not wrong, and this Parisian cool isn't idleness – it's flamboyance.

It's the 'Parisienne cool' of famous models, designers and muses such as Loulou de la Falaise, Inès de La Fressange or Caroline de Maigret. In French, the 'de' in someone's name indicates that their family is descended from nobility, and a whole line of well-born Parisiennes with this aristocratic particle in their name embodies this unique blend of nonchalance and bohemianism – a sort of scruffy sophistication.

Sophie Fontanel also has this quality. She was born in the very aristocratic sixteenth *arrondissement* on rue des Vignes, right in the midst of the great Parisian bourgeoisie. Her family wasn't rich; her mother was an Armenian refugee who had arrived in Marseille a few years earlier with her collection of *Vogue* magazines in one hand and Sophie's father in the other. 'I grew up in buildings where you still had pantries and back stairs. As a child, I'd often cross paths outside our apartment with women who wore scarves round their heads like Jackie Kennedy, and whole families heading to Mass or the synagogue. I grew up thinking my family had won the lottery because we lived in the sixteenth. But what I wanted was to live in Saint-Germain-des-Prés so I could walk to Café de Flore. My parents were dismayed.' In fact, later in life, Sophie spent several years living in a one-bedroom apartment on rue de Verneuil, a stone's throw away from Saint-Germain-des-Prés. She held a large number of meetings at Café de Flore where, as soon as it hit five o'clock, she would always order a glass of dry white wine and a small plate of *saucisson*. I know this because, back then, Sophie and I worked together at *Elle* magazine. I was much younger then and couldn't get over sharing such perfect Parisian moments with the woman who was my mentor and would become one of my dearest friends.

Despite all that, Sophie tells us the Flore is far from being the most iconic place in Paris. Indeed, she has a rather elaborate theory about Parisian cafés. 'I knew I was Parisian from an early age because I had friends who always wanted to go to trendy places like Costes

or Café Beaubourg, but I preferred going to the local bar. Because Parisians have a knack of making the waiter at the local bar switch from being insufferable to pleasant and friendly. You make him get to know you, make him like you and then make him agree to bring you a little pot of Chantilly cream with your coffee.'

On the day we meet up with Sophie, she's halfway through a long-term project: stopping dying her hair black (as she has done for many years), and instead allowing the white to take over completely. Sophie shares everything with her followers on Instagram, who will soon have the chance to read about her experience in more detail because Sophie is writing a novel about it – something she does whenever life offers her an opportunity. Her book will certainly resonate with thousands of women across the world. Indeed, while pouring us a cup of roasted rice tea in a floral porcelain tea set (the pattern is very similar to that on the sheets of a large bed we notice at the end of a row of rooms), she tells us she's just this second put the phone down on a call with an American *Vogue* journalist fascinated by what she's doing. What Sophie is basically highlighting is the very Parisian assertion that a woman's life is not limited to her youth. That you can grow old without having to resort to cosmetic surgery, and can still be modern and attractive. 'There's an enormous job to be done in moving this idea forward. But the job is not an intellectual one. You have to embody it physically.' This is a process that requires a certain amount of courage alongside the confident but laid-back attitude that Sophie described earlier.

She tells us that letting her snow-white hair come through has meant she has had to go through all the intermediary stages and deal with delightful remarks from people in the fashion world. One such comment came from a stylist at Fashion Week who said, 'You know men will never like it,' to which Sophie immediately replied, 'But since when have men known what they like?' So, Sophie does what she pleases. Especially when it comes to clothing. It's impossible to

pop in to see her without her diving into her dressing room at least once to show off her latest purchases: this time it's a high-waisted denim skirt by Vanessa Seward. The place where she keeps her clothes is a dream. There are special compartments for handbags, hat boxes overflowing with scarves, neat stacks of cotton T-shirts and beautifully folded cosy sweaters. But the space is far from bursting with clothes. There are a few pieces on rails and just two pairs of boots, which is surprising if you take a look at all the photos of different outfits Sophie posts on Instagram. She prefers not to keep anything long-term, and offloading regularly has become a natural habit. 'I spend time buying timeless things I get bored of,' she laughs. 'I only keep items I've hunted down in vintage shops or really sentimental things, like this sofa that my mother reupholstered or that piece of furniture which belonged to my aunt Anahide. I even get ride of books. I don't need to keep books to show I read.' And that's what makes Sophie an icon: her profound airiness.

# Our Paris.
## Appreciating what's natural

When Jeanne tries to describe what she means by 'natural', she says, 'What you love about your partner is their broken tooth, their slight squint. What you love about Sonia Rykiel is her striking red hair. In Vanessa Paradis, it's the gap in her teeth. In Juliette Greco, it's her Roman nose.' The word 'flaw' really irritates us. Flaws only exist if you work on the assumption that 'perfect' smiles, hair or eyes also exist. We both hate strict, superficial definitions of beauty: there are a thousand ways to be elegant, to be a woman. The feminist movement talks about 'self-care', an expression taken from militant Anglo-Saxon culture. It means the right to love yourself as you are, to take care of yourself without feeling guilty. People have a fundamental right to love themselves completely, both physically and psychologically, for both their strengths and their weaknesses. All the women in this book radiate 'naturalness'. In other words, they don't feel the need to 'perfect' or enhance their appearance, they're completely themselves.

# Faubourg-Saint-Martin
## *with* Jesus Borges

*Amazonian butterflies*
*Favela Chic*
*Workman's overalls*
*Éric Rohmer*

There was something both unpredictable and inevitable about meeting Jesus. Jeanne bumped into her one evening in a bar during her nocturnal meanderings. She fell head over heels for a girl in sky-blue workman's overalls, and decided we needed to go back and check out this young woman who runs one of the hippest restaurants in Paris right now: the Jesus Paradis on Passage du Marché in the tenth *arrondissement*, renowned for its crab beignets, chicken in orange and unbelievable Caipiroska cocktails. A few days later, Chloé, our French editor, called to say she'd just left a meeting at Jesus Paradis, and the girl who ran the place was seriously classy, loved literature, and we really had to meet her for the book!

Basically, it was impossible not to include Jesus. Jesus – her first name alone is enough to grab people's attention – is from Cape Verde, she's forty-four and has lived in Paris for twenty-five years. She has an apartment with sky-blue walls plastered with cinema posters and scattered with real, naturalized butterflies that she's hunted down in charity shops like Emmaüs. That's how, one autumn afternoon, Jeanne and I end up sitting with Jesus, hanging on to her every word. This is the story of a woman who's literally created everything for herself, all by herself.

Nothing predestined Jesus to become a restaurateur, idolized by artists and writers. There was nothing in her past to suggest she was going to be the owner of a venue hidden down a little passageway in the tenth *arrondissement*, where regulars only mention the address in hushed tones because they're afraid it may lose its unique charm. Jesus dreams that one day there'll be a literary prize organized here to reward young Parisian authors. In fact, head chef, Anna Dubosc, has written four novels already.

But Jesus had to fight for her Parisian dream. Her tenacity and vision remind us of other businesswomen who have made their mark on Paris, like Coco Chanel or the journalist Hélène Lazareff, and who, like her, were shaped through adversity. 'I came to Paris by coach, arriving at the Gallieni bus station in 1992,' she recalls. 'It was August and scorching hot. I was nineteen years old. I'd come from Lisbon, where I was living with my father. I couldn't speak a word of French.'

If you want to understand Jesus, you need to listen to her talk about culture. Her bookcase is sagging beneath the weight of all her books: she reads us a long passage by Svetlana Alexievich, a Belarusian writer who received the Nobel Prize in Literature in 2015, and admits she regularly returns to the published correspondence of Louis-Ferdinand Céline. She also spends time watching plays and ballets at the theatre. She mentions Pina Bausch, whose choreography she recently saw at the Théâtre du Châtelet, Philip Glass's chamber music concert at the Philharmonie cultural institute and the latest performance of Shakespeare's *Henry IV* at the Odéon-Théâtre. She tells us about her artist friends, such as the Madagascan Joël Andrianomearisoa who came up with the brand identity for Jesus Paradis.

At least once a week, Jesus walks to one of the cinemas in the Quartier Latin (La Cinémathèque, Le Champo or Le Reflet Médicis) so she can take in a few old films by Éric Rohmer, her

favourite film director. She's seen his movie *Le Signe du lion* (*Sign of Leo*) twenty times. 'I love going to the afternoon showing when there's a couple of old people commentating out loud on actors' performances, and then afterwards I like to settle down in a *vieux rade* to have a cup of tea.' She says '*vieux rade*', a colloquial term for an 'old, local bar', in a very slight Cape Verdean accent, and it's pure poetry just listening to her speak Jean-Luc Godard slang.

Jeanne and I are amazed at her knowledge and the way she makes the most of the cultural experiences Paris has to offer, experiences that most people born here forget they can have too. That aside, Jesus is not just intellectually focused, she also loves fashion, and has an inimitable style. She has a knack for unearthing stunning pieces at ridiculously low prices, and when she puts different items together, she always creates elegant outfits. In fact, she sometimes works as a stylist on film sets and other shoots. And she has achieved all that by herself as well. 'Not one thing was passed on to me. I came from a place where there was nothing. That's why people often question me on my intelligence,' she says, 'they're surprised at how much I know. But it's a thirst, a need. My father used to say one thing to me: learning doesn't take up much space.'

Jesus worked relentlessly so she could understand and enjoy all this spiritual nourishment. 'My primary goal was to speak fluent French. It was a basic necessity. I didn't want to live like my sisters, closed off within the Cape Verdean diasporic community. I wanted to tear myself away from all that, get involved in Parisian life. I watched a lot of television to try and understand the country I'd just arrived in, and each time someone spoke French to me, I thanked them. I was speaking the language fluently after three months.' She then gave birth to a little girl, Lisa. Initially, Jesus worked for a family as an au pair in Crétail in the south-eastern suburbs of Paris, then she edged closer to the city centre when she landed a job as a waitress at Favela Chic, a Brazilian bar/restaurant-cum-club between République and

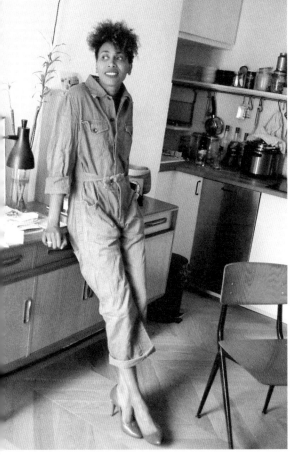

canal Saint-Martin. It still exists today. But back then young Parisians thought it was the centre of the universe, the place you had to go to see and be seen. And everyone wanted to see Jesus. 'I was a little bit pretty,' she says, smiling humbly, 'but I knew nothing! I'd never even served a meal before, never made a cocktail. But, I don't know how, I became a sort of icon there. People went there to see me, and even now, sometimes in Barcelona or New York, people speak to me about the time I worked there. It's mad.' She sighs, and you can tell that she wishes people would leave her alone about that.

These days, her greatest passion is her bar/restaurant, Jesus Paradis, which has been open for two years now. And Paris, obviously. The friends and acquaintances she's made here feel like family to her. 'This is my home, I'm not moving again.' She admits though that at one point she wanted to go and live in Lisbon because of a man. Love is her Achilles heel. 'Love and relationships have provided a rhythm to my life,' she admits. 'I could leave the man I loved for one look from someone I bumped into on the street. Romance fascinates me. You meet someone and hey presto, you can't imagine living without them any more. Those kinds of encounters, they only really happen on the streets of Paris, they turn your head and your heart. Something knots up your stomach, and then one day it disappears. I could talk about love for hours.' Essentially, it feels to us that Jesus embodies passion, something that is better expressed in Paris than anywhere else.

# Our Paris.
## In Paris, in love

Being in love in Paris can be exquisite – but it can just as easily be overbearing, as the romantic cliché of the city puts immense pressure on lovers in the capital. Paris is supposed to be overflowing with romance from morning till night, as depicted in everything from Doisneau's iconic photograph *Le Baiser de l'Hôtel de Ville* (*The Kiss by the Hôtel de Ville*) to some of Woody Allen's films. But we all know that, just like anywhere else, there are couples in Paris who tear each other apart, come to blows after a crappy evening, share lives that become dull, and people who are eternally single. We could have chosen to abandon all this soppy romanticism and shatter the myth completely. But we decided not to. They say Paris is the city of love . . . It's a cliché, but one we'd like to keep.

**Places we've been kissed in Paris (in our dreams):**

I. On the Ponts des Arts bridge after attaching a padlock to the railings.

II. On the second floor of the Eiffel Tower while the sun sets.

III. On the big wheel at the place de la Concorde on a beautiful summer's morning.

IV. At the foot of a weeping willow by the Rosa Bonheur bar in the parc des Buttes-Chaumont.

V. On a Seine riverboat pontoon, one spring evening.

VI. Sheltered beneath a large umbrella one October night on boulevard Saint-Germain.

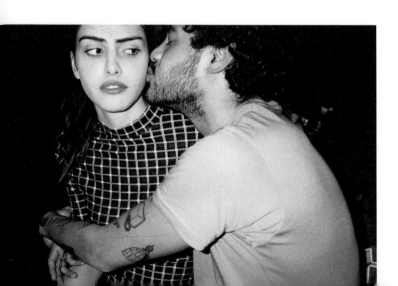

**Places we've been kissed
in Paris (genuinely):**

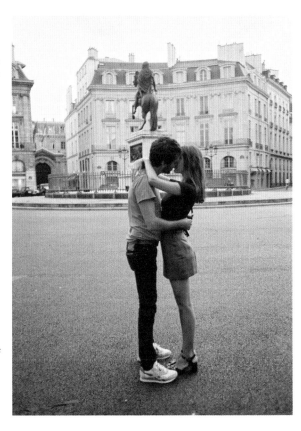

I. Hidden in the shrubs in Saint-Jacques Tower gardens on rue de Rivoli.

II. Locked away in a private changing room at the Molitor swimming pool.

III. On a night bus at around 2.30 a.m. on the way to porte de Champerret.

IV. By the bins at Chez Moune club on rue Pigalle.

V. Under the counter at Mauri7, a bar on rue de Faubourg-Saint-Denis.

VI. In the seafood section of the Picard frozen food supermarket on rue Beaubourg.

VII. Sitting on a pavement – we couldn't tell you exactly where.

VIII. Freezing cold in the outside seating area of a bar, under the heater, after going out for a cigarette.

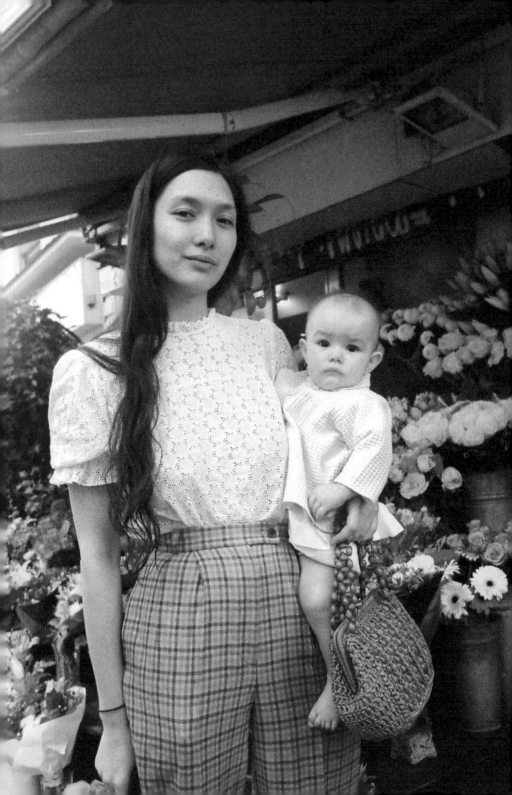

# Canal Saint-Martin
## *with* **Noemi Ferst**

*France Culture*
*Behind the decks*
*Arts Décoratifs*
*Le Baron nightclub*

At Noemi's place you get to meet Gigi, her adorable little baby who was just three and a half months old on our visit. She's dressed in cotton pyjamas, performing vocal exercises in her bouncer. Noemi is still adapting to having a baby, but in a guilt-free, typically Parisienne way. 'I breastfeed her at night, but I haven't stopped smoking. I take her everywhere with me, to the office, out for dinners, parties, although we never get back late.' France Culture is murmuring away on the kitchen radio, the breakfast table hasn't been cleared, there's a bunch of wild flowers inhabiting a speckled vase. A turntable and piles of vinyl records put the finishing touch to the interior décor. There are also a few items of clothing lying around and an alluring ray of sun reflecting off the sun-shaped mirror which has pride of place by the front door. Welcome to Noemi's.

Do you know the song 'La Bohème' by Charles Aznavour? Well, Noemi is the embodiment of that song and the bohemian lifestyle it conveys, the dream of a more just and simple world, of consuming poetry at the expense of eating at a set time. The word *bohème*, incidentally, first appeared in Paris at the start of the twentieth century near Montmartre. Noemi and her boyfriend, a DJ/artist/entrepreneur, married in India a year ago. They live just a stone's throw

from the canal Saint-Martin, a *quartier* that's become popular with so-called 'bobo' (bourgeois bohemian) residents. Indeed, it's no coincidence that the area was targeted by terrorists on 13 November 2015. When we interview Noemi, the memory of the attacks is still fresh in our minds and quickly comes up in conversation. 'We'd been here almost a year,' she recounts while pouring a glass of milk. 'We wanted to escape the ninth *arrondissement*, which has been completely gentrified. These days, all you find there are cafés with timber facades selling gluten-free cakes. Here we get to experience the more earthy side of Paris, a blend of cultures . . . I have a little market, a café, a florist.' One of the terrorists fired shots from the outdoor seating area of La Casa Nostra, just outside Noemi's. When she heard gunshots ringing out from the street corner that evening, she leant out of the window and saw a man fall to the ground right in front of the flower stall. 'I'd just found out I was pregnant. At first I wanted to escape to the country. We saw the local services cleaning blood off the pavement. For two months it was like a mausoleum outside. There was a feeling of indescribable sadness in the air. But what shocked me most was the way the press maintained the levels of panic, and the government too, by continuously prolonging the state of emergency. So I decided I needed to stay, to fight.'

Noemi was born in Los Angeles. Her mother is half English, half Chinese and her father is Israeli–Polish. She spent a while living in Hong Kong, and then London, until her family set up home in Paris. She was seven years old at the time. 'I learnt to speak French when I was four, because my parents sent me to French school in Hong Kong. The first time I saw Paris, I found the city so bright, so hypnotizing, and I didn't want to go back to London, a cold, wet city where it gets dark at 4 p.m.

Her wish was granted. She moved with her parents to an apartment block in the sixteenth *arrondissement* where she had a romantic, creative childhood. Very early on, Noemi knew she wanted to be

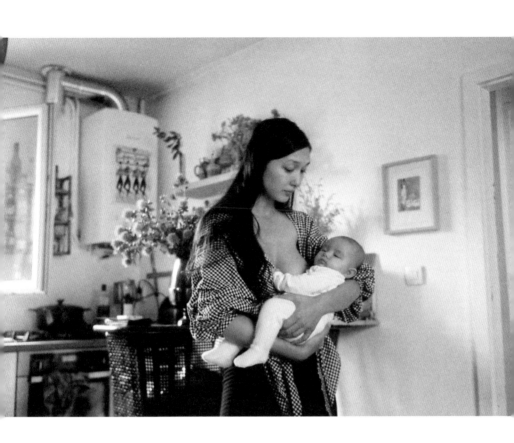

an artist. She rejected the traditional education system and refused **92**
to take her *Baccalauréat*. But for six years, she attended workshops
at the famous École des Arts Décoratifs, a prestigious art and design
college. There she refined her pictures of floral motifs and delicate
collages. And then there was night-time.

And night-time had a name: Le Baron, a small nightclub on
avenue Marceau in the eighth *arrondissement*. Young Parisian party-
goers would swarm there every evening. I met Noemi for the first
time on one of these nights at Le Baron. She was seventeen then
and would either be wearing 1940s dresses or pompoms stuck to her
breasts, and she would spin records all night. She formed part of a
pioneering generation of female Parisian DJs or 'DJettes', as they
were called. The carefree atmosphere permeating her apartment, her
way of life, how she brushes her hair away from her shoulder to take
Gigi in her arms and latch her on to her breast, all remind me of the
freedom that used to blow me away at Le Baron. 'Back then, there
was something completely magical about the nights we spent there.
It was a carefree, easy-going time. It was a time for all kinds of gath-
erings, all kinds of freedom.' Her appetite for self-expression has now
been channelled into her militant feminism; the birth of her daugh-
ter has had a big influence on this. 'I have become aware that soci-
ety looks at women who are breastfeeding in a way that makes those
women feel guilty. Looking at them in that way transforms some-
thing pure and natural into a dirty deed. The way women's bodies
are objectified is intolerable. Free the Nipple! Why do men have the
right to go bare-chested and we don't? The other day, in the street,
a man insulted me because I'd stopped on a bench to breastfeed. A
group of young judokas were walking past with their mums, and they
all started to shout over him. It was a triumph.'

She also extends her fight to Instagram, where she posts photos
of flowers, her baby and herself, completely naked. And in terms of
music, she recently launched a joint project with her husband: an

*Quartier du canal Saint-Martin*

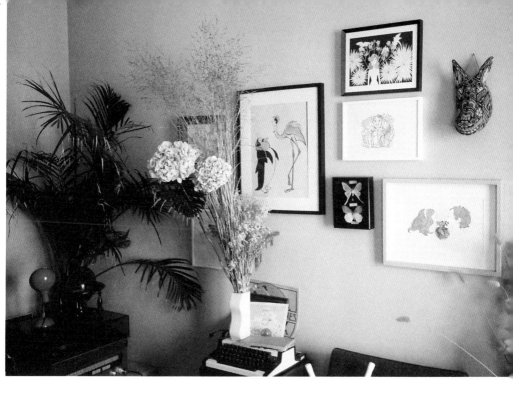

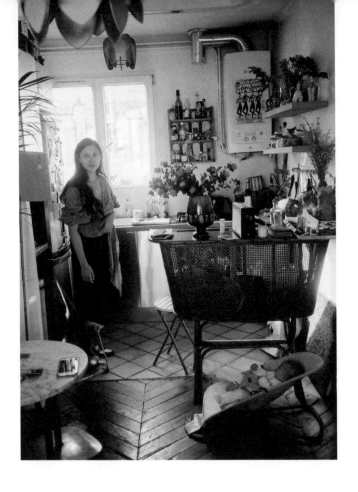

extraordinary site called Radiooooo, where you can select and listen to songs from all over the world according to decade, from 1910 to the present day.

'We have contributors from four corners of the world. One of our most active contributors lives on a small island off the coast of Brazil and collects old 78s. Over five hundred tracks are sent to us every day. We make a selection, so we only keep the best. Every morning, we read our emails. This morning, for example, a blind filmmaker sent us a message to tell us we had changed his life. It's our way of making the world more open, more enjoyable.'

# Our Paris.
## (Well-) educated kids

When it comes to bringing up children in Paris, a relaxed approach is the norm. Of course, there are some 'mother hens' who drop everything as soon as their child comes along. But in our circles, and if we go by tales that Parisiennes have told us about their own childhoods, it seems children in the capital don't always rule the roost.

**Ten things children do in Paris:**

I. Sleep half the night on a double bed between two piles of coats while their parents dine in the next room.

II. Sleep with a baby monitor on, because their parents are dining with neighbours on the same floor and don't see the point of getting a babysitter.

III. Walk to school on their own at the age of eight.

IV. Go to concerts from the age of five, with protective headphones over their ears.

V. Have six goes in a row on the merry-go-round on Sunday evening, because Papa ran into a mate at the café over the road.

VI. Splash about at the public swimming pool on Saturday morning because Maman has her Aqua Aerobics lesson at eleven.

VII. Know the difference, from the age of four, between a soldier (the man with a gun who walks past school each morning) and a CRS officer (the man with a riot shield who appears when there's a protest march).

VIII. Completely colour in the paper tablecloth at a restaurant while Maman and her friend finish their glasses of Morgon.

IX. Sit down for an hour in the book section of Monoprix while Papa stocks up with food for the week.

X. Throw dry bread to the ducks in parc Monceau and feel insanely in touch with nature.

**Twenty hundred-year-old names given to Parisian children this century:**

Honoré
Colette
Françoise
Marcel
Barnabé
Appoline
Balthazar
Célestine
Achille
Augustine
Joseph
Jacques
Blanche
Bernadette
Marius
Suzanne
Jacqueline
Ernest
Alphonse
Madeleine

# *Boulevard Voltaire*
## *with* **Valentine Maillot**

*Dancing*
*A suitcase*
*Three children*
*A Chanel delivery*

She was a dancer in her first life, then a model, a mother and an editor-in-chief, and today she's puffing out cigarette smoke with baffling elegance, replying, '*Je ne sais pas.*' That's Valentine: moody, but with a disarming charm. Parisienne icons such as Brigitte Bardot, Françoise Sagan and Isabelle Huppert, the ones the world envies, never have the big toothy smiles of American stars. At best, they have an air of melancholy and at worst they look a little exasperated, meaning they get almost everything they want, including the world at their feet. Valentine is that kind of Parisienne. She represents a Paris that's both elegant and a little weary, a Paris dressed in Chanel that hangs contemporary photography on its walls, a Paris covered in sequins, but still, a little lethargic.

Valentine lives on one of the wide boulevards in the eleventh *arrondissement.* You would never guess that just beyond the busy traffic and crowded pavements lie secret patches of green, nestled in little courtyards. Her modern, two-storey house has its own cobblestone terrace. It's the first day of summer and we feel at home sitting at the teak table that takes pride of place here. And actually, we really are a little at home because Valentine's children are friends of ours. We've already spent many an evening here, sipping rosé beneath the

large parasol. Valentine was often there, with her husky voice, youthful figure, black jeans, and her short, brown hair in a wavy crop. For almost always, the slightly feigned weariness depicted above comes with limitless generosity, a zest for fun and a profound need to be surrounded by friends, wine, culture and happiness.

Those are the two sides to Valentine's personality and to the life she leads in Paris. She has both Catherine Deneuve's reserve and Françoise Dorléac's exuberance; the calm composure of the North and the fiery temperament of the South. In fact, Valentine carries these two pieces of France within her. She grew up in Lille but her mother was from Marseille. Her mother 'was the only person in the

city to cook in olive oil', she recalls. At the age of thirteen, she left Lille on her own to go to Nice, where she boarded at a prestigious dance school. Nureyev even taught her classes there in the summer. She learnt how to be independent, only returned home three times a year, did all her own laundry, and developed the solitary and determined nature of a future principal dancer. She was a young prodigy in a hurry to make her mark and, as a result, she passed her *Baccalauréat* at sixteen and a half and moved to New York. She lived in a shared apartment on West Broadway and, thanks to a scholarship, she joined the Dennis Wayne ballet company, where she worked twice as hard as before.

'I've lived all over the world, but my roots are in the South. I brought my olive trees with me,' she tells us, pointing out the Anduze pots scattered around the place. 'I like Mediterranean colours, the warmth – my grandfather was from Corsica.' It was only around ten years ago that Valentine decided to make Paris her home, so she could move on from a separation. 'My destination was a foregone conclusion: it had to be Paris. I needed culture, I needed to thrive! A friend of mine came across this house and courtyard. I instantly felt at home, as if this place had always been waiting for me. I've made friends in the *quartier*. I lead a village life in Paris. Everything is right outside my front door.'

As the sky darkens and it threatens to rain, we decide to head inside. The living room has high ceilings and the white walls are covered in works of art. Taking centre stage is a photo of her and her daughter taken by Oliviero Toscano for *Elle* magazine in 1987. Valentine was a top model in the 1980s and inspired some of the world's greatest photographers such as Peter Lindbergh, Richard Avedon and Steven Meisel. She still has strong connections to people in the fashion world from this period of her life, as well as exquisite taste in clothes and it-girl status even now that she is fifty-five.

And as it happens, the doorbell rings while we're chatting. It's a

delivery from Chanel. 'I was scouted by a modelling agency while I was waiting in baggage reclaim at a London airport. I was eighteen years old. At the time, I burst out laughing. It didn't seem quite right to me! The girls in magazines back then were all Swedish, very blonde and very tall!' Valentine accepted the offer and for a few years she did nothing but travel, her favourite thing in the world. To illustrate her point, she takes us down to the basement where she keeps all her clothes. There are bags, shoes, items of jewellery, and she shows us a few classic pieces she guards safely there, combining them with little gems she picks up at private sales. Amongst all that, we find stacks of carry-on designer suitcases with wheels. 'Even now, I love packing my case knowing that an aeroplane awaits me. I slip in a sweater, a stole, a few books and an evening dress. I wear my Gucci mules and a soft pair of trousers for the flight, I pop on a pair of large sunglasses, grab a tote bag and off I fly.'

She's always lived liked that, turning the pages of her life in a way that's both sudden and definitive. 'Modelling is a real job, one that consumes your life. Personally, I needed the theatre, children, exhibitions – I needed to live. But I really must admit that it was much less consuming than dance.' She met her husband when she was a model. He was a high-profile choreographer who had fallen madly in love with her when he saw her face on a billboard. They moved to Tours, where she gave birth to three children in six years, putting her modelling career on hold. 'I realized then that I was very alone. Friendships are constructed over a period of time, and I had done nothing but travel. I could have moved anywhere.' Then her husband was transferred to Monaco. She moved to Nice, where she spent time connecting with her southern roots. And finally, years later, she rediscovered her independence when she landed a job at a luxury magazine in Paris. As if it was meant to be. As if it was the only place that could quench her thirst for aestheticism. A place that would appease her nomadic spirit. However, she admits it's much harder these days.

*Quartier deVoltaire*

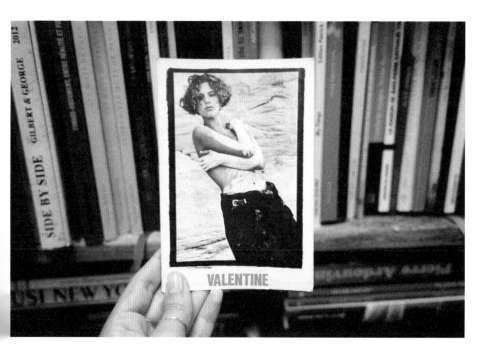

She's mostly referring to her children here: she says she feels anxious about the times they live in.

'In the 1980s, you didn't ask many questions, children earned more than their parents, they embraced their independence and built a life for themselves.' Her twenty-five-year-old son, who has a great job in fashion, sleeps upstairs. She lets her eyes wander across the living room, piled high with books, posters, photos, drawings, works of art and postcards. She loves this space, which is exclusively hers and where she keeps little mementos of all her experiences. 'Here I live the opposite of the nomadic life I led previously. I found my harbour. That harbour is Paris.'

*Quartier de Voltaire*

# Our Paris.
## Dinner *chez-moi*?

We can't help it – we've inherited our parents' quintessentially French tradition of inviting our friends round for dinner.

Even when these dinners have been planned for a while, they always have to involve a little morsel of improvisation. Every guest brings part of the meal, so we move from a dozen oysters to a beef and carrot casserole, not caring if the two go together. A cheese board and a few bottles of white usually go down well, on condition, of course, that the table is dressed beautifully with a tablecloth, elegant wine glasses, a fruit basket and some candles. The aim of the game is to prolong the fun, because the best confessions always take place after midnight. *Apéritifs* should finish as late as possible so that dinner is served at 10.30 p.m. and the conversation draws to a close very late, at the tail-end of the meal.

**Lauren's Provençal casserole recipe:**

A. Take a large cast-iron casserole dish.

B. Finely chop a white onion and brown in the dish with two large cloves of crushed garlic.

C. Add 1kg of diced beef (ask the butcher to chop the beef for you in advance), and fry until golden brown.

D. Peel 1kg of carrots and cut into batons. Add these to the casserole dish.

E. Cover with a litre of red wine, ideally a Côtes du Rhône.

F. Add a bunch of thyme, a stem of rosemary, two bay leaves, a clove and a few summer berries.

G. Cover with a lid and leave the casserole dish on a very low heat.

H. Allow to simmer for at least four hours.

I. Enjoy.

# On Île Saint-Louis
## with **Emily Marant**

*Takeaway coffees*
*Loafers*
*A legendary aunt*
*An island on the Seine*

The way Emily sees it, Paris is really small. Sometimes, she's been known to travel back and forth across the city six times in twenty-four hours. Emily's Paris can be held in the palm of your hand. She knows all the little nooks and crannies, even the most secret ones. Emily's Paris is the Paris of all young girls from well-to-do families: Parisiennes who spent their teenage years zipping across the city on their mopeds and passing their evenings in huge, empty apartments abandoned by adults.

On the day of our interview, there's a sleepy romanticism floating over île Saint-Louis, an extraordinary little island right in the heart of Paris where you bump into more tourists and school trips than authentic Parisians. We stop to buy takeaway coffees at the local café on the corner of Emily's street. The waiter raises an eyebrow but seems used to this kind of request, although ordinarily only from Americans. Emily asked us to come and meet her on the island at a stylish apartment belonging to her family, a sort of bachelor pad that has been passed on many times from one tenant to the next. A little earlier, she'd been on the phone apologizing for not being able to invite us round to her place (she has a friend staying in her studio apartment in Le Marais), and asking us to bring her up an espresso.

Emily is under pressure. As a young businesswoman, her apartment functions both as a base camp for her work and as a safe haven for friends passing through. Because of this, her belongings are scattered all over the city, at friends' apartments, at her father's, it doesn't really matter to her, as long as she keeps on moving. Her hair is damp, her T-shirt is slightly creased and she's wearing Klein Blue loafers from J. M. Weston, the French luxury shoe company. She doesn't stop looking at her phone, commenting when an email pings, sighing when a text appears. She's with us but also elsewhere, welcoming and receptive as well as overwhelmed and overworked. A year ago, Emily created Studio Marant, named after her grandfather's photography studio on boulevard Haussmann, a competitor to Studio Harcourt at the start of the twentieth century. She advises on art and design, and promotes limited edition art. Everything in Emily's life revolves around art and creativity, and it's been that way since she studied graphic design and marketing at Ravensbourne college in London, then at Berkeley College, New York, followed by Mod'art in Paris.

Her friends include Sébastien Meyer and Arnaud Vaillant, young designers best known for reviving the Courrèges fashion brand.

In her free time she enjoys scouring the flea market at Saint-Ouen and wandering around museums such as the Musée Maillol, where she did an internship, or the MAMO museum of modern art in Marseille, where she often goes for the weekend.

She talks about her life with a childlike smile that you imagine helps her get away with anything. It's the kind of smile you only see on the face of a Parisienne. Don't tell Jeanne, but she too has a disconcerting ability to mix brusqueness with charm.

When Emily was growing up, her time was divided between the capital and the Nice hinterland, which explains her profound need to get back to nature and regularly nip off to the South. Her memories of being a little girl in Paris waver between mansions in Neuilly-sur-Seine and an artist's courtyard in Montreuil, where she would rub shoulders with wrought-iron craftsmen. Her mother came from London's intellectual elite and brought her up speaking the language of Kate Moss. Combine all this with a Martinican step-grandmother, internships in Shanghai, a gap year in New York and an everlasting affection for the historic Parisian *faubourgs*, and you get Emily. The Paris she describes is restless and encompasses suburban Boulogne as well as the more-upmarket Maisons-Laffitte, Le Grand Rex art deco cinema and Saint-Germain-des-Prés.

Thanks to her nomadic childhood, she's developed a habit of never sleeping in the same place for two nights in a row. Like all fashionable girls in the capital (Emily is the niece of the legendary Isabel Marant, who's been a leading Parisian designer for over twenty years), you can't talk about her life without mentioning Parisian nightlife. She remembers being seventeen and going to Pulp, a nightclub on one of Paris's Grands Boulevards, and dancing all night long to electro beats from Miss Kittin and DJ Chloé. She also recalls evenings with friends that would start by the canal Saint-Martin and

eventually end up at Favela Chic; she had the kind of nightlife that would be envied by students the world over. It was only after she went to art college in London that she decided to settle down and find herself a little bolthole in Paris (her apartment in the third *arrondissement* that we won't get to see). 'I live at the intersection of several different versions of Paris: the dodgy Paris around rue Saint-Denis where I love to hang out, and the more bohemian Paris around rue de Bretagne where I can go and buy fresh produce from the Marché des Enfants-Rouges.'

She says she feels most Parisienne when she's smoking a cigarette outside a café, no matter which café it is. She seems most Parisienne to us when she casually reveals that she never wears make-up. She also only ever walks or uses the métro to get around because, according to Emily, Paris is tiny. 'My assistant, who comes from Marseille, has never walked as much as she does here.' She embodies her own definition of a Parisienne, which she sees as a woman who is 'very active, lives thirty lives at the same time, works hard, self-educates, is constantly on the move; a girl who looks people up and down a bit too, not in a snobby way, but she observes – we observe a lot in Paris, don't we?' We do, and we observe her too, amused by her nervous energy as she arranges a bunch of sweet peas in a vase on the fireplace, alongside a sculpture of a dog and a few books, items she's brought to make the place look more personal. All of a sudden, she stops doing three things at once and grabs hold of an art book, flicks through it and shows us an image. Finally, she takes a breath.

# Our Paris.
## Rocking red lips

If there's one gesture that encapsulates Paris, it must be the seductive act of applying red lipstick. Red lips with a natural, almost nude face. Here are a few tips from the women with the most enviable red lips in Paris.

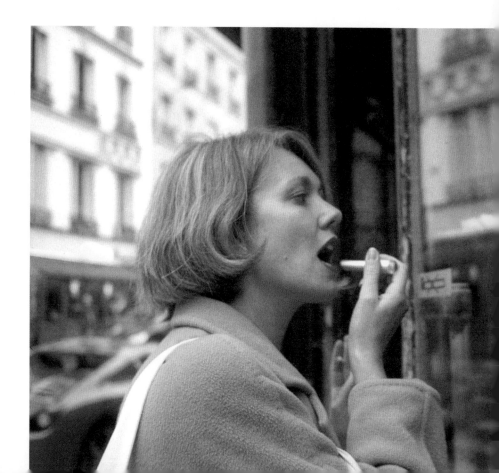

**Lauren's lipstick**
Matte 370 by Shu Uemura

**Photographer Saskia
Lawaks's lipstick**
Ruby Woo by MAC

**Jeanne's lipstick**
Rouge Velvet 08 by Bourjois

**Film director Rebecca
Zlotowski's lipstick**
Le Coquelicot by Rouge Baiser

**Photographer Sonia Sieff's
lipstick**
Rouge Coco Carmen
by Chanel

**Shoe designer Amélie
Pichard's lipstick**
Jungle Red by Nars

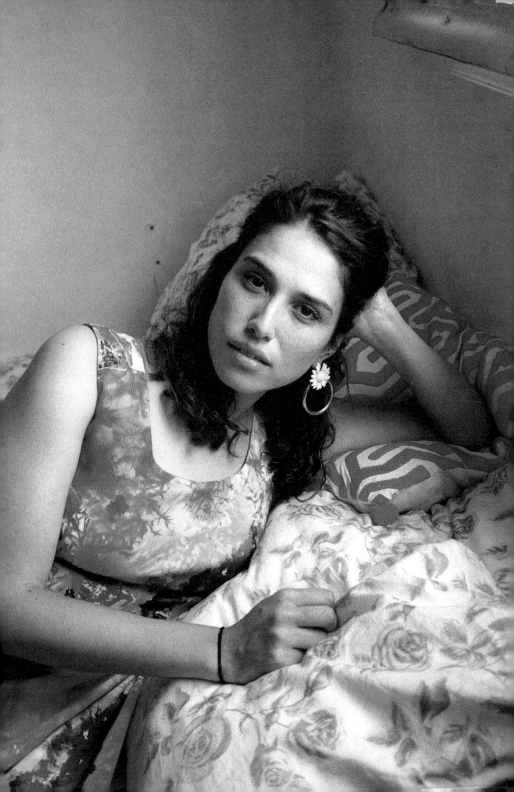

# Place Pereire
## with Dora Moutot

*Trolls*
*Birkenstocks*
*A gazette*
*Gardeners*

Parisiennes are frequently considered to be purveyors of good taste, permanently wearing navy-blue sweaters and white Stan Smith trainers. But such an assumption would be incorrect, especially if you take Dora into account. We came across Dora while surfing the Internet. She's a journalist and created *La Gazette du Mauvais Goût* (*The Bad Taste Gazette*), a website where she indulges her passion for anything kitsch. On the site, she publishes unashamedly vulgar videos and images in psychedelic colours. She is a fan of ridiculous objects, preferably ones that are sparkly and bright purple. Like an anthropologist would, she explores a part of the human psyche that really fascinates her. So, it's no surprise that she greets us dressed in an outfit that is very different to the usual Parisienne uniform. She's wearing a bizarre fluorescent tie-dye dress, silver Birkenstocks and sparkly green nail varnish. She begrudgingly invites us in, saying she's had enough of her building, describing it as a pile of bricks, something you'd find in Berlin. Jeanne and I feel strangely comfortable there. We settle down on her broken white sofa with our takeaway coffees and listen to her stream of atypical teenage memories of a little-known side of Paris that is both weird and wonderful.

Dora spent part of her childhood here near the place Pereire at

the heart of the family-friendly, residential seventeenth *arrondisse-ment*. Dora is clearly sick and tired of the *quartier* but she recognizes one good point at least: the local council pays its gardeners well. 'I'm obsessed with flowers and they have a sizable flower budget here. Occasionally, I just grab my camera and go and take photos of bushes and flower beds. Sometimes I walk as far as Levallois, Bagatelle or the Bois de Boulogne.'

Dora has little quirks, as many of us do. But let's just say that she has more of them than the average person. Her particular fondness for the peculiar perhaps finds its roots in her childhood. Her mother was born in Israel and her father in Algeria. She was born in Washington and has lived in the Parisian *banlieue*, as well as Frankfurt, London and New York. She gives us a quick rundown of the different periods of her life, but they are all mixed up, and it's quite difficult to put them in chronological order. However, we gather from her story that she's had a journey that's as idiosyncratic as the building she lives in. 'My parents have seriously bad taste. My father wears socks with sandals, my mother was so beautiful that she never made an effort with her clothes, in fact she still doesn't. Fashion doesn't interest her at all. She used to have a Sanofi promotional backpack instead of a handbag. They taught me the meaning of irony.' It's very true, Dora is not lacking in irony. She employs euphemisms and puns with particular gusto. 'My parents live abroad, my sister is in San Francisco, my friends in Brazil or Germany. Paris stands out to me, it's the city I know best. I lived here from the age of four to seven, and from fourteen to twenty. I always come back here. My two grand-mothers are also here. I am incredibly close to them.'

She tells us about *her* Paris, where she's lived alone since she was seventeen: Châtelet-les-Halles, where she would go and get piercings and have her hair dyed, the Grouft, a Gothic shop where she would buy clothes, the Batofar for punk rock concerts and Andrea Crews for its imaginative fashion performances. And, finally, the second-hand

shops and stalls on rue Richard Lenoir and Belleville, which are the best places for quirky, kitsch, made-in-China-style bric-a-brac.

'Since I was a little girl, I've always loved pink things and My Little Pony. I have never grown out of them. When I was a teenager, I explored pretty much all subcultures: punk, emo, cybergoth. When I started studying, I was in full *kawaii* mode. I stuck ribbons everywhere. My teachers, who were more the Margiela type, would constantly say, "Dora, you have such bad taste!" I created the *Gazette* with this sense of irony in mind.'

Her frivolity and humour remind us of some of the great intellectual Parisiennes such as Simone de Beauvoir or Claire Bretécher. Like them, she has a preoccupation with clothes, a stylistic flamboyance to accompany her ambitious ideas. In fact, her obsession with textiles has led her to launch a new project, a documentary on traditional and contemporary dress in emerging countries so that viewers can discover a country through its clothing culture. She's already filmed the pilot in Morocco. Dora herself is not afraid of creating shockwaves with what she wears. She's tried everything, and people

in her *quartier* have long been familiar with her rain hood with cat ears and her fluorescent Dutch bicycle. 'The kind of guys I've gone out with have varied. My first boyfriend was a skateboarder I met on CaraMail, but I dumped him when he got dreadlocks. After that there was a guy with a four-kilometre-long platinum blond streak flopping in front of his face.'

When she's divulging her love life, Dora suddenly changes, which is common in Paris when you start talking about love. You'll notice someone's tone of voice changes, they start waving their hands around, interrupting people. Everything becomes urgent and passionate. You have to join the debate, give your opinion, recount your experiences, look for answers. Dora is a traditionalist. 'I'm a romantic, I have an old-fashioned view on couples. I don't want to have children outside marriage. I often feel out of synch with the whole hook-up culture. Our generation doesn't take its time, people sometimes sleep with each other too soon. I believe you should be desired for a while first.'

# Our Paris.
## Let's dance

Parisiennes like tiny nightclubs where you have to queue for hours to get in and end up saying it's only worth going on a Thursday or not at all. The rest of the time, we improvise.

**Noemi Ferst's Playlist:**

I. 'Sans mensonges', Marie Gillain

II. 'Nana', MSTRD

III. 'Season to Season', Lynsey de Paul

IV. 'Love in Space', McLane Explosion

V. 'Paris, Paris', Josephine Baker

VI. 'Classé X', Jane Birkin

VII. 'It's All Up to You', Jeanne Mas

VIII. 'Starlight', Risqué

IX. 'Most of All', Saint Tropez

X. 'La Parisienne', Marie-Paule Belle

# In Belleville
## *with* **Lola Bessis**

*Ricotta and spinach parcels*
*Dungarees*
*John Cassavetes*
*A café-bar*

*Breathless, Cléo from 5 to 7, Moulin Rouge, Amélie, Children of Paradise, Hôtel du Nord, Zazie in the Metro, Bed and Board, When the Cat's Away* and even *Ratatouille*: the cinema loves Paris as much as Paris loves the cinema. So it was difficult for us to paint a complete picture of Paris without talking about the film industry. An opportunity to do just that came about in winter when we bumped into Lola Bessis, a young actress, screenwriter and director adored by critics. We really wanted to feature Lola in our book as she has a very Parisian way of rocking up to the red carpet at film festivals featuring films she's directed: with her hair always a bit messy.

Lola was born in the fourteenth *arrondissement*, to a Tunisian father and an Italian mother, and she grew up near parc Monceau. These days she shares her life with her boyfriend, whom she met at the age of nineteen. He's also a filmmaker and three years ago they co-wrote and co-directed *Swim Little Fish Swim*, her very first film. It's an enchanting, highbrow, independent full-length feature film produced on a very small budget. The plot takes place in New York, where they lived for five years so they could pursue the dream they both shared.

'It would have been harder to produce our film in Paris. It's easy to edit and produce independent films in New York. It was my first film as a director and as an actress. The city provided me with the best possible education. But I received recognition for it back here!' The film has been awarded a number of prizes. It tells the story of a young Frenchwoman who doesn't want to leave New York, despite having visa problems. She moves in with a couple, sub-letting their sofa, and develops a connection with an underrated artist. Lola's story is a little like that of the heroine in her film. By leaving Paris, the city where she was born, she grew to understand fully what the capital means to her. 'When I came back, I realized I didn't know Paris. My childhood in the seventeenth *arrondissement*, the Lycée Carnot, made me lose sight of the more colourful, contradictory side of the city. New York helped me to see Paris in a different way.'

When we met up with Lola, she'd just moved to Belleville, a vast, hilly *quartier* with both modern buildings and traditional narrow streets, hip restaurants as well as more mainstream bars. Historically, the *quartier* is known for housing immigrant populations, and has always been one of the capital's more vibrant, multicultural areas. Édith Piaf lived in Belleville, Willy Ronis photographed it, Romain Gary set his novel *La Vie devant soi* (*The Life Before Us*) here and the film *Casque d'or* (*Golden Marie*), starring Simone Signoret, took place in this neighbourhood. An increasing number of Parisian 'bobos' (and we admit to being two of them) dream of moving here so they're closer to the entertainment at La Bellevilloise arts and cultural centre as well as the lawns at parc des Buttes-Chaumont. Lola and her boyfriend have achieved this dream. Their apartment is a sort of loft and they're planning on knocking down all the walls to allow as much light as possible to enter their home. When we arrive, there are boxes that have not yet been unpacked, and her boyfriend is still in bed. And as there are no chairs or cups of coffee, we decide to decamp and

conduct the interview at a local café on boulevard de Belleville where a small espresso at the bar costs one euro.

Lola is a bit embarrassed because she doesn't have a great deal to tell us about her little patch of Paris right now as she's just moved in. The area she knows like the back of her hand is on the other side of the Seine, in the sixth *arrondissement*, near the cinemas in Saint-Michel. Just yesterday, the couple were still living there. 'We were in the same building as Le Saint-André-des-Arts cinema. The auditorium was right below our lounge. It was a sign! We'd sometimes find mail addressed to the cinema in our letter box. Eventually, we forged links with the people in charge of the theatre and we'd sometimes organize viewings of our work. I used to dream of running evening events there, where we'd show little-known, independent American films and then continue the evening at our place over a drink and vegetarian food.' She lists a whole load of films including *Lenny and the Kids* and *Mad Love in New York* from the Safdie brothers, *Putty Hill* by Matt Porterfield, and more. 'I love cooking like my Italian grandmother. I stopped eating meat and fish at the age of seven and I've always prepared my own dishes. In fact, my ricotta and spinach pastry parcels are famous throughout Paris!' She seems a little nostalgic about her former home. 'It was a really old apartment, very beautiful, with "Versailles" parquet flooring. Everything in our home was second-hand. The old 1970s yellow sofa from our film set was brought back from New York. The rest we got from Emmaüs [a second-hand store].' She's the same when it comes to clothes. Today she's wearing a denim dungaree dress which fits her like a glove, and her cool, bohemian style has been thrown together using vintage pieces she's unearthed in second-hand shops all over the world, from Athens to Los Angeles.

Four years after returning from New York, a desire for change led them to Belleville. Their apartment is the centre of their world. They work from home, always together, and invite scriptwriters here. She

admits they 'operate in a rather isolated way'. Their recent move is not the only upheaval in her life. Her acting career is also taking off in France. 'I'm beginning to meet people, put a show reel together, genuine offers are coming in.'

If it all works out, she'll need to get over her fear of red carpets. 'When I was little, my parents had to force me to pose for family photos. I couldn't stand it, I always sulked. I slowly developed a taste for it. John Cassavetes is my greatest inspiration. He acted in major studio films and used the money he earned to produce his own movies. It gave him freedom.' And according to Lola, her path to success and love for her city will go hand in hand. 'I'm in the middle of writing a film I'm going to direct on my own. It will take place in Paris, but only at night. We don't really know what goes on in the city at night.'

# Our Paris.
## Wearing a trench coat

We know for a fact that every single woman we met for this book owns a trench coat, often a second-hand one that hangs on their coat rack throughout summer and winter. They wear it when it rains (often), they wear it mid-season (around ten months per year), when they go out in the evening, hanging out on Sundays, when they dress simply, when they want to look chic, when they work, when they relax, when they want to look attractive, when they want to blend in, when they're in good shape, when they're feeling down, when they're wearing jeans, when they're wearing a dress, when they feel feminine, when they want to go for a masculine look, when they're dancing, when they're working hard . . .

# Gare de l'Est
## with **Dorine Aguilar**

*Bordeaux*
*A boyfriend*
*A little car*
*Vintage clothes*

You should have seen Dorine's face when her boyfriend, Elliott, burst into the apartment right in the middle of our interview. 'I told you not to come over!' she screamed, blushing as he laughed. Elliott is adorable and in love. Dorine is adorable and in love. If our book had been about Parisian couples, they would definitely have been on the cover. They've been together for over ten years now, and met on Myspace (an old social network you won't know if you're under twenty), and it's partly because of Elliott that Dorine left the suburbs of Bordeaux for Paris seven years ago.

For Elliott, and also partly – well, primarily – for dance. Paris and dance have always gone hand in hand. Few places do dance as well as Paris does, whether it's ballet, hip-hop, films such as *An American in Paris* or the Bastille Opéra. Futures are forged around this art form, which is both a discipline and a way of life. There are dance schools all over the capital, including the *banlieue*. In fact, Dorine teaches at one of them. Every evening she teaches routines to amateur dancers aged between six and sixty-six, as well as running a '*handidanse*' class for disabled adults in Gagny, Seine-Saint-Denis, in the *banlieue*. That's why she has a car, a little Ford Ka, which is an unusual possession in a city where you can never find anywhere to park.

'I finish very late and didn't want to come back on the RER train. And as we live in the Quartier Indien, people work here but don't sleep here, so I can always find a place to park in the evening.'

Dorine was ten when she discovered her passion and future career. 'That's very late for a professional dancer,' she says, but it was a revelation. She had back-to-back lessons and summer courses in classical dance and then hip-hop. This morning, seeing Dorine in her little apartment in the Quartier Indien, a serious look on her face and a cup of tea in her hand, it's easy to imagine her as the conscientious, focused and well-behaved teenager she must have been. You can hear the rumbling noise of buses and traffic congestion from Gare de l'Est, which is just a stone's throw away. Dorine's cat rubs up against my notebook. A heavy May shower taps away against the window. There are textile merchants zigzagging down her street, pushing trolleys weighed down with shimmering rolls of fabric. The grocery shop just outside her apartment sells spices and incense. And on the corner there's Sol Semilla, one of the hippest vegan restaurants in Paris right now. Dorine pours us another cup of tea and continues her story.

When she was seventeen, she was offered a place on a training course for professional dancers, but she was also tempted by law. So she did both: university and dance. A year later, she was spotted and asked to join a show called *Urban Ballet*, dancing hip-hop to music such as Ravel's 'Bolero'. The show was a huge success and gave her the opportunity to travel all over the world, many times over. She toured for three years before ending up in Paris, enlightened and more than ready to face real life. There was no hesitation when it came to choosing where to live. It had to be the tenth *arrondissement* because Elliott was settled in Gare de Nord and her parents lived near canal Saint-Martin. Like most Parisians, she can't imagine changing *arrondissement*. As long as it's there, so is she.

Dorine likes to get up early 'or else I feel guilty', she says. She drinks litres of coffee, some orange juice, and then devours slices of toast with Nutella (you should know that she dances for seventeen hours each week as well as doing three hours of yoga). In the morning she rehearses for any upcoming auditions. She laughs as she tells us about the strained atmosphere between dancers while waiting for musical auditions, and the crazy comments that come from the mouths of contemporary choreographers, such as 'I like dancing when there's no dancing.'

She feels most Parisienne when she's on a bike hurtling down the embankment by the canal Saint-Martin, crossing paths with all kinds of people: 'Indian women in saris, dads with pushchairs, that's what makes Paris for me – this multicultural, crazy, familial, happy side that became even stronger after the attacks on 13 November.' In the evening, Dorine likes to invite friends over for one of her boyfriend's pasta dishes.

We head out so we can take a few photos around the *quartier*. She may well have the super-strong look of a true Parisian girl on a rainy day, with her trench coat cinched in at the waist, but some things she says do betray the years she spent living in the provinces, where shops still close between midday and two o'clock. 'There's always something to do in Paris,' she declares, reeling off a list of places including the Cinémathèque film library in Saint-Germain-des-Prés, Le Champo art-house cinema in Jussieu, hip-hop nights at Wanderlust (a large open-air nightclub on the banks of the Seine) or even the Bikram yoga classes Dorine attends at least three times a week (they're on at all hours). Dorine still talks of 'going home' when describing the weekends she spends in Bordeaux, but no doubt that will stop in a couple of years.

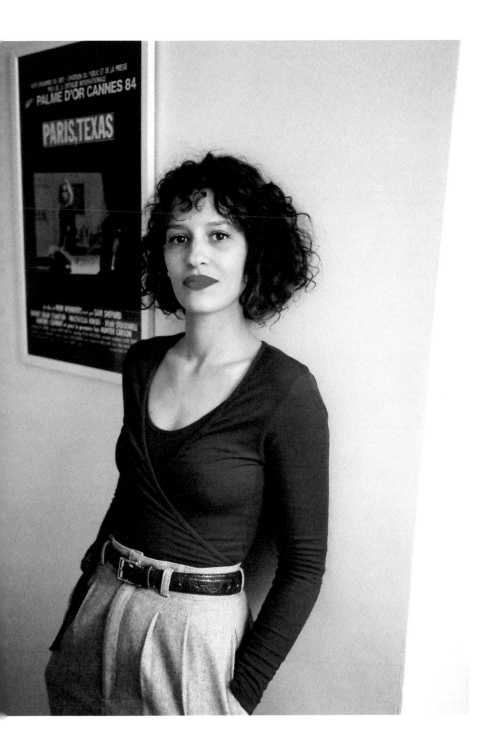

# Our Paris.
## The art of vintage shopping

**Ten vintage items you should own:**

A trench coat
A tweed jacket
A silk shirt
A bucket bag
An American university
  sweatshirt
A Fair Isle sweater
Levi's
A flowery dress
A jumpsuit
A long Indian-style skirt

**The best vintage clothes shops in Paris:**

*Kiliwatch*,
rue Tiquetonne, 75003

*Kilo Shop*,
bd Saint-Germain, 75006

*Guerissol*,
avenue de Clichy, 75018

*Le Coffre*,
rue de Ménilmontant, 75020

*Rag*,
rue Saint-Martin, 75004

*Ketchup*,
rue Dancourt, 75018

*Rose Market Vintage*,
rue Hippolyte Lebas, 75009

*La Mode Vintage*,
rue Rochebrune, 75011

# By Notre-Dame
## *with* Sylvia Whitman

*A bookshop*
*William Burroughs*
*Scottish boarding school*
*Gabriel, two and a half*

Sylvia Whitman is radiant, bubbly and approachable when she greets us at the Shakespeare and Company bookshop on the banks of the Seine. It's an autumn day and Paris is gilded in shades of red and orange. The Seine riverboats ripple the water below Notre-Dame Cathedral as we sit down at a table in the little café adjoining the bookshop and prepare to indulge in apple and pear smoothies and avocado toast. Sylvia seems very British to us with her good manners, use of irony, her floral dress, blue eyes, the way she orders a cup of tea at the bar, and her delicious accent as she tells us stories about her dog, Colette, whom she takes for a walk every evening along the embankment.

Then again, she could be the most Parisian of all the women we've met. Paris has run through her veins since early childhood, and like the heroine in a novel, her life has had a series of unexpected twists and turns, sometimes extraordinary, sometimes romantic, sometimes tragic. And Paris has always provided the backdrop to such unforeseen events. Each and every one of them. Her picture-postcard Paris serves as a setting for the bookshop she inherited and now runs (along with her husband, she manages a team of almost forty people working at both the bookshop and the adjoining café).

Sylvia Whitman's domain is like a cross between the worlds of Amélie Poulain and Esmeralda: you can see the green metal boxes of second-hand booksellers along the banks of the Seine, the Pont au Double bridge, the river's Cité island and the tips of the towers on Notre-Dame Cathedral as they pierce the sky. 'Notre-Dame amazes me every day. I've never seen the same light twice on the steeples.' She describes her life like the opening of a novel, and her city like a poem. Even if you're a bookseller, you can tell your life story that way only when you live in Paris.

'I was born in l'Hôtel-Dieu hospital, just opposite, on île de la Cité. My mother was in the bookshop when her contractions started. She rushed across the bridge from the other side of the Seine so she could give birth there. When I was little, that was where I went to nursery. I have very warm memories of my early childhood in Paris. I remember the light that filtered through the windows of our apartment, the smell of the métro and *boulangeries*.' Sylvia Whitman is the daughter of George Whitman, an erudite American who fell in love with Paris after World War II and decided to move here 'because he wanted to live in a city where people are poets and life is poetry'. In 1951, he founded this bookshop on rue de la Bûcherie, and in 1964 he renamed it Shakespeare and Company. Whitman took the name from an old bookshop run by another Sylvia, Sylvia Beach, at the start of the twentieth century on rue de l'Odéon. In her bookshop Beach had mixed with the likes of James Joyce, Ernest Hemingway and F. Scott Fitzgerald. In the 1950s in George Whitman's shop, it wasn't that unusual to bump into Allen Ginsberg or William Burroughs. 'My father was an eccentric character and a bit of a Don Quixote. If he was bored during a reading, he would burn his hair. For him, a world outside the bookshop didn't exist. He always left the bookshop door open so that the world could dive right in. He had a lot of thefts though.

"'Be not inhospitable to strangers, lest they be angels in disguise" is inscribed on one of the beams in our bookshop and was a very important motto for my father and increasingly important in my eyes, when you see what's happening in the world. He'd travelled a lot, especially in South America. He was thirty-eight when he opened the bookshop. And he was seventy when I was born.'

She was still very young when her parents divorced, and she ended up in London with her mother. She had almost no more communication with her father at that time. She went to boarding school in Scotland where, she tells us proudly, she wore a kilt every day. She continued her studies in London and didn't see her father again for almost ten years. 'And then at the age of twenty-one, I suddenly realized that he was ninety-one and I needed to see him again before it was too late.' George greeted his daughter in a very casual manner, introducing her to everyone as an English actress called Emily. 'But he threw me into the bookshop and passed everything on to me. We became best friends. I wasn't a big reader before. And it was then that I fell in love with the bookshop and with Paris.'

Sylvia continues to tell us her story as she takes us on a tour of Shakespeare and Company, a maze of wood and stone. The charm of Paris as it used to be long ago is captured in the low ceilings, uneven floors and wobbly stairwells. Rue de la Bûcherie dates back to the twelfth century. Since 1951 the shop has also accommodated many writers in residence, both on couches within the shop itself, and now in George's former apartment above. In keeping with a tradition established by George Whitman, each author who sleeps at Shakespeare and Company must write a single-page autobiography for the shop's records. Sylvia shows us a heavy binder crammed with these literary testimonies. 'This binder is full of Parisian dreams,' she says.

Sylvia tells us anecdotes about the capital that we've never heard before. For example, she knows that the oldest tree is in square René Viviani, and that Jane Birkin and Serge Gainsbourg met at Hôtel

Esmeralda, just a stone's throw away. But she has nothing to envy the legendary couple as her first encounter with her own husband sounds like something from a classic romantic novel. 'He was writing an essay on Shakespeare and came into the shop because he was looking for a rare book. I said I'd take his phone number, something I never do! I'm still looking for his book . . .' Their son, Gabriel, who is two and a half, has just made his first recommendation. He took five books off the shelf for a grandmother who was looking for something for her granddaughter. The family lives just a short walk away on rue de Pontoise, opposite the most beautiful swimming pool in Paris. 'My intention was to go there every morning at 7 a.m., but obviously that's not happened,' she says with a laugh. However, Sylvia has become an expert in the art of roaming Paris.

'I have a bike, I love cycling to see my friends in the eleventh, twentieth or ninth.' She likes to experience private moments in the city, strolling alone on the banks of the Seine in the morning. Or she likes to cross the Seine with a writer in the dead of night to find slightly seedy places and reflect upon Brassaï or Henry Miller while wandering past some street or other. 'In London you're always thinking about the dress or car you need to buy. I don't think like that when I'm here. In London, everything revolves around money. Here, everything revolves around poetry.'

# Our Paris.
## Becoming a culture vulture

Paris has a reputation for being very rich in culture. Art, theatre, literature, poetry or photography are everywhere you look. Obviously, there's the Louvre, Beaubourg, the Théâtre du Châtelet and Fondation Louis Vuitton, but there is also a more secret side to Parisian culture that we'd like to help you discover, a Paris that extends far beyond the *boulevard périphérique*.

*Le Bal*, for its photography and video exhibitions.
6 impasse de la Défense, 75018

*Le 104*, a place of cultural creativity.
104 rue d'Aubervilliers, 75019

*La Fondation Henri Cartier Bresson*, a leading centre for photographic art.
79 rue des Archives, 75003

*La Bibliothèque de l'Université Paris 8*, the largest university library in France.
2 rue de la Liberté, 93526 Saint-Denis

*Le MacVal*, a contemporary art museum. Place de la Libération, 94400 Vitry-sur-Seine

*Le théâtre Gérard Philipe.*
59, bd Jules Guesdes, 93200
Saint-Denis

*Le théâtre des Quartiers d'Ivry* in
La Manufacture des Œillets.
1 place Pierre Grosnat, 94200
Ivry

*Le 116*, contemporary art centre.
116, rue de Paris, 93100
Montreuil

*Mains d'œuvres*, contemporary
creative arts organization.
1, rue Charles Garnier, 93400
Saint-Ouen

*Les laboratoires d'Aubervilliers*, a
centre for experimentation and
the emergence of new art forms.
41, rue Lécuyer, 93300
Aubervilliers

# In Ménilmontant
## *with* Crystal Murray

*A bomber jacket*
*Marvin Gaye*
*Régal'ad sweets*
*Silencio members' club*

There's nothing much in Crystal's demeanour to indicate she's only just reached her teens, aside from her carefree laugh and the fact she drags her trainers along the pavement. She's only fourteen years old, but her self-confidence and the way she gazes directly into the camera when posing for photos are enough to fool you into thinking she's an adult. Crystal lives in Belleville near all the modern buildings on rue Max Ernst, and opposite square des Amandiers. It's a little less glamorous there than on rue de Ménilmontant, which is just a short walk away. Crystal has lived here with her family since she was little. 'It's ultra central, you can walk to République.' Her father's American so she's developed a distinctive kind of language, a kind of 'franglais', meaning her French is peppered with English phrases such as 'don't ask' or 'so strange'. She also uses a lot of teenage French linguistic quirks such as *'chais ap'* (from *'je ne sais pas'*, 'I don't know') or *'archinormales'* (totally normal).

Crystal is the personification of a key, mythical Parisian figure: a teenager who has grown up in the capital. Sophie Marceau, one of the most revered actresses in France, has even played that character on our cinema screens in *The Party*, a cult film for all Frenchwomen who grew up in the eighties. Crystal would be the twenty-first-century

version of this character. Crystal and her four friends, all fifteen or sixteen, are well known throughout the East of Paris and fashion parties across the city. Together they're known as the 'Gucci Gang', though they're not formally linked to the luxury Italian brand. They remind you of groups of kids in French films such as the mischievous girls in *Peppermint Soda* or the independent teens in *Girlhood*, directed by Céline Sciamma. 'I don't know what we are in fact. We have a sort of bizarre notoriety, there are articles on us in gossip magazines like *Public* and even in Germany. We're just totally normal friends, all different but we like the same things, especially travelling and buying clothes in vintage shops.' Totally normal but Parisian right down to their Champion-branded sweatshirts. They're very current, bold and skilful at combining sequins with streetwear, which has turned them into muses for a new generation of Parisian stylists and labels such as Pigalle, Études Studio and Vêtements.

Before we find a suitable place to interview Crystal, we quickly pop into her parents' place, where we get to see the jumble of clothes littering her teenage bedroom floor. A record player takes pride of place in her room, and there's an old Marvin Gaye disc on there, ready to play. *Bye Bye Blondie* by Virginie Despentes is open on the bed at the page where she finished reading last night. We decide to go and sit outside a café nearby. She asks for a cup of tea and puts her Samsung mobile on the table. It doesn't have Internet access. We're surprised because firstly, we innocently thought that the younger generation was even more hooked on technology than we are, and secondly, we found Crystal on Instagram. But that's Crystal. She's surprising and full of contradictions, as you need to be if you're a Parisian teen who's destined to be idolized. With a crooked smile on her face, she recalls her childhood, which was not that long ago.

She lived 'a perfect childhood', she says. Spoiled and cosmopolitan, with lots of travelling. Her father is a musician, she's 'seriously close' to her mother, and her three brothers make a fuss of

her. Growing up, her parents carted her everywhere, from Mexico to Japan. 'When I was eleven, I was far too well dressed because of my nineteen-year-old brother. I used to copy him. I wore a bomber jacket. In fact, it was his bomber jacket.'

Since Sophie Marceau's *The Party*, climbing over the wall at fourteen and showing off in a club is a necessary rite of passage for Parisian teens. So, she obviously started going out in secret to fashion parties at Social Club, Silencio and Le Carmen. She's surprised no one has stopped her getting into any of these nocturnal Parisian haunts, when 'everyone knows my age', she says cheekily. She laughs telling us how she had the nerve one evening, not that long ago, to go to a Pigalle fashion party right after taking her national diploma exams. There's an air of brazenness and mystery developing in her,

which is something we noticed in her older counterparts in this book. Crystal can throw you off balance, she puts up a smokescreen. One minute, she frowns sadly as she revisits the difficulties she faced at the Catholic private school she attended for a while. 'It didn't go at all well,' she exclaims. 'They wanted me to cut my hair. I was really upset when I wasn't accepted to stay on and do my *première générale* year there [penultimate year of high school], but I'm going to go to regular school, which will be better.' The next minute, Crystal boasts, 'I'm comfortable in my own skin, I like myself just as I am. I think that's what a Parisienne is, a girl who is free, who does what she wants, *peu m'importe.*'

Crystal likes to do her own thing. We don't know if that's a generational characteristic or something that's specific to young Parisians,

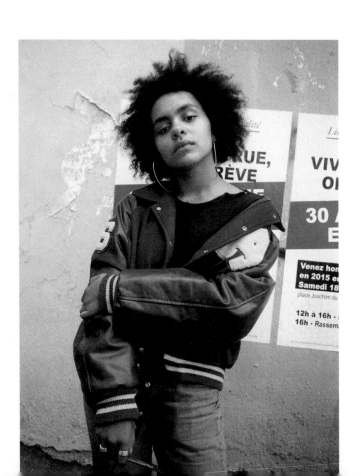

but we notice she doesn't follow any particular, mapped-out plan. She's constructed an identity for herself: 'You don't have to be someone to do what you want'; a style: 'Every day I wear the same Levi's 501 jeans, sometimes with an XXL American football shirt I've nicked off my dad, and the following day, with a satin negligée that my mother has given me'; a cuisine: 'Every lunchtime I buy a cheap Sodemo Roma salad, sometimes we go and have a picnic in the Bois de Vincennes or else I go and meet my mother on rue du Chemin Vert for a Vietnamese omelette. Otherwise, I stuff myself full of Régal'ad fruit gums'; a beauty routine: 'I'm often really tired and it shows as I never wear make-up. The only make-up I wear is a bit of gloss on my eyelids when I go out. And when the dark shadows show up too much under my eyes, I put cotton-wool pads soaked in chamomile on them.' And even when she's talking about love, she'd rather die than admit she lacks experience or maturity in that area. Her verdict on love is definitive: 'Parisiennes always lose their heads a bit when it comes to guys, but I don't, I'm anti-love.'

We could almost find this touching if Crystal didn't seem quite so strong and sure of herself. We spend our lives bound by news alerts on our mobile phones, a knot in our stomachs worrying about contemporary threats in French and international politics, so we quiz Crystal on her own vision as a young woman who was fourteen when the November 13 attacks took place. 'It was awful, I was meeting up with my friends at République that evening, and my mother was at a concert. After the attacks, I spent several weeks shut away at home. I know the world is horrible, but I don't want to be freaking out all the time, I don't want to be thinking permanently about Donald Trump and Marine Le Pen. I know that if everything happens as they want it to, that will be shit. But a new generation is emerging which is going to change the world.' We don't dare to contradict her; and hope that some of her confidence in the future will rub off on us instead.

# Our Paris.
## Buying flowers

A Parisian apartment is not complete unless it's filled with vases of flowers. Seasonal flowers are best, so preferably mimosa in winter, daffodils and lilacs in spring, bellflowers and sunflowers in summer and dahlias in autumn. In Paris, you buy flowers to say thank you, to say well done, to say anything at all. And every Parisienne has her own particular florist that she just can't do without.

**Addresses for our florists:**

*Arom,*
73 avenue Ledru-Rollin,
75012

*Variations végétales,*
18 rue du Général Guilhem,
75011

*L'artisan fleuriste,*
95 rue Vieille-du-Temple,
75003

*Les succulents cactus,*
111 rue de Turenne, 75003

*Debeaulieu,*
30 rue Henry Monnier, 75009

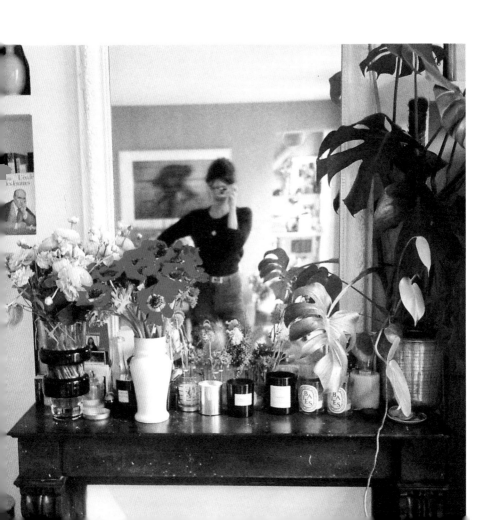

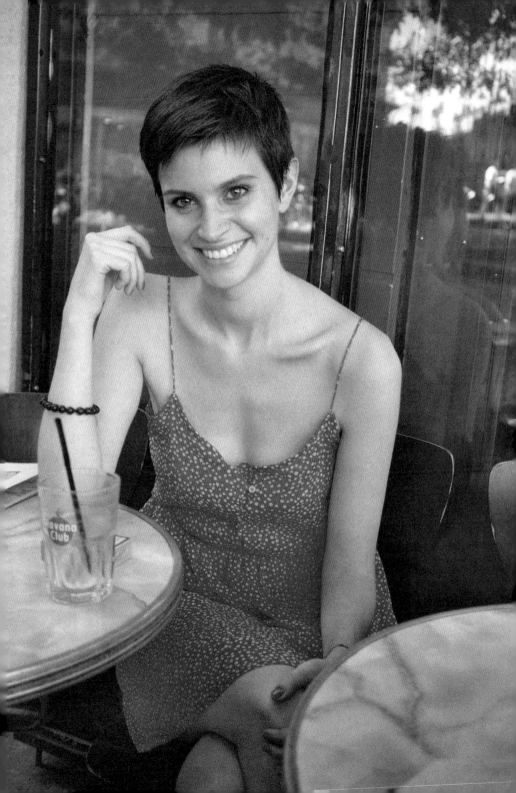

# In Sopi
## with **Lucie Hautelin**

*Nuit Debout*
*A haircut*
*Veganism*
*Twitter*

I fell head over heels for Lucie when I came across a photo on Twitter. It was spring 2016, and the place de la République was filled every evening with throngs of protestors, some young, some less so, outraged and overflowing with an intense desire to change the world. It was part of a social movement called Nuit Debout (Arise at Night). We went there many times to breathe in the air of rebellion, to talk to committed Parisians who fostered values that some branded utopian but that we prefer to think of as humanist, even visionary. Place de la République is a very symbolic square in Paris. It represents the heart of politics in the minds of Parisians. We've protested there a number of times over the last few years. There were millions of us there on 11 January 2015 after the *Charlie Hebdo* attacks, and again to mourn the dead on 13 November the same year. We've also thrust our fists in the air to protest against violence towards women. And each time we cross the square, we hear slogans in our heads, starting with the national motto engraved on the *arrondissement* city halls: '*Liberté, Égalité, Fraternité*'.

The photo I found of Lucie on Twitter that evening communicated all of that. It was taken on the fringes of a demonstration against the Loi Travail (Employment Law). Lucie had a scarf

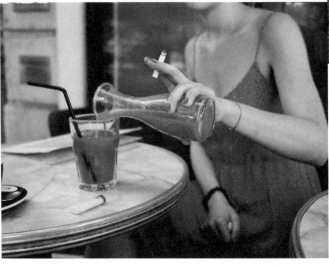

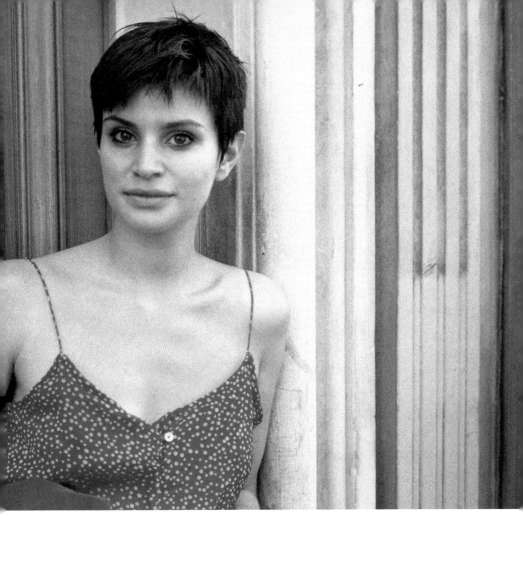

tied round her neck and a pair of swimming goggles on her fore-head to protect herself from the tear gas being fired at protestors by police. She had a look of utter determination on her face. She instantly reminded me of some of the great female revolutionaries, especially during the French revolution of the late 1700s. Olympe de Gouges, the social reformer and writer, springs to mind, as well as Louise Michel, the 'red virgin' who fought with the National Guard to defend the Paris Commune against the Versailles troops in 1871. Then there are the early-twentieth-century Suffragettes and the militants from the Mouvement de Libération des Femmes, the women's liberation movement who created a stir in Paris after the civil unrest and strikes of May 1968. Paris is a city of rebellion, a city of protest, a city that flourishes with social progression. And you could see all of that in Lucie's eyes too.

After a few enquiries, we managed to get in touch with her. Lucie lives near avenue Trudaine, a short walk from my place. We meet up with her on the corner of her street while she's chatting to a boy sitting on a skateboard. They're both part of a Nuit Debout anti-speciesism commission. Lucie is vegan and has made that one of the cornerstones of her political activism. 'It's easy to show the links between animal rights and the financial and ecological crisis!' she enthuses. 'I don't consume any animal products, I don't wear leather, fur, wool, or use cosmetics tested on animals. I drank milk until I went to visit a very reputable dairy farmer. The cows were completely exhausted. After you've witnessed that, it's impossible to carry on consuming dairy products.' She smiles and comments that the *quartier* is perfect for vegans (she's right, they've got Le Potager de Charlotte here, a renowned vegan restaurant). And she tells us about the last film she was in called *Chair Liberté* (*Liberated Flesh*), a short dystopian piece directed by Déborah Biton, which depicts a world where human beings, rather than animals, are raised for slaughter.

Lucie is an actress as well as an activist but only agrees to do films

that 'convey meaning'. 'My ultimate aim in my role as an actress is to use my reputation to inspire other people and change the world.' Like many budding young actresses, she pays her rent thanks to a few restaurant jobs on the side. 'I spend very little. I salvage discarded objects, I buy clothes from Boutique Solidaire, I only eat vegetable products, and I put all my money aside so I can travel. Last summer, I went to Peru with a total of €500 for everything.' She recently worked as a barmaid in a private club. 'During the week I fought lobbyists and at the weekend I made them mojitos,' she says mischievously.

We're sitting outside a café in a pretty square between rue Rochechouart and rue Turgot. We're at the heart of the gastro-nomic ninth *arrondissement*. In this *quartier*, every street corner has a *boulangerie–pâtisserie*, and the narrow streets and lack of green spaces don't seem to dissuade families with young children from living here. This area of the ninth is called SoPi, short for South Pigalle, and shares a lot of similarities with Brooklyn. Members of the male pop-ulation have beards here, the most common form of transport is the bicycle and the majority of restaurants offer gluten-free dishes. Lucie orders a tomato juice that matches her red dress.

She's always been an activist. Even when she was at senior school, she was involved in social movements against the government's lib-eral reform of the work market, and has always hated injustice, prob-ably because of the difficulties she herself faced in childhood. Lucie was a child of the DDASS (Direction Départementale des Affaires Sanitaires et Sociales, the government department that looks after French orphans); her parents were unknown, she was adopted, a victim of abuse, but she took strength from her experiences. 'I had to create my own place in the world, because no one ever gave it to me. At the age of twenty-one, I went over to Canada wearing trainers and a backpack. That trip was so educational. It was a sort of pilgrimage that instilled in me a desire to open up to the world. Then I lived and worked in London for a while. I felt as if I'd lost my direction in life.

I realized I couldn't live in this capitalist system.' She lists the books
and films that inspired her to become an activist: *Eichmann in Jeru-salem: A Report on the Banality of Evil* by Hannah Arendt, *Earthlings*, a documentary by Shaun Monson, the film *A Quest for Meaning* by Marc de la Ménardière and Nathanaël Coste, obviously *The Second Sex* by Simone de Beauvoir, but also *The Green Beautiful*, an ecological film by Coline Serreau.

Back then, Paris didn't feature in her future plans. 'Every time I came back here, I was insulted, I experienced a number of difficulties on the métro. These days, I feel more Parisian than provincial, I'm in my element. Everything moves much quicker both intellectually and culturally speaking.'

One evening in April, she was hurt by a stingball grenade in République. 'Police officers dehumanize activists,' she stresses, still awash with anger. 'In my opinion, their repressive violence is more illegitimate than any violence from protestors. That evening, I met my boyfriend, a journalist working for an alternative media outlet. He treated my injury. I had a hard hat and pair of goggles on and was carrying a sign. It was very romantic despite my activist gear.' She tells us about the emotion she felt every evening in place de la République when she met up with other Nuit Debout protestors. 'I like the feeling that history is watching me, that all past rebellions are etched into these places. I would go there every evening, and every evening I would tremble there, I would cry. I gave a speech to the general meeting of the anti-speciesism commission, and it was picked up on all the social networks. We learnt from that, we realized that social media is a tool we can use for political purposes, to campaign, and we created

our own network, we became more structured. We're at the tipping point, we have reached the limit of something.' And that something was born in Paris. Could it have emerged anywhere else? She smiles then sighs. 'I'm not objective any more,' she says, 'I love this city like mad. The adoption was successful this time around.'

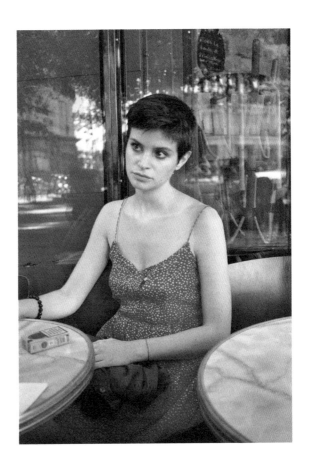

# Our Paris.
## Politicizing your life

**Books to read:**

*We Should All Be Feminists,*
Chimamanda Ngozi Adichie

*A Room of One's Own,*
Virginia Woolf

*The Right to Choose,*
Gisèle Halimi

*Beauté fatale,*
Mona Chollet

*The Second Sex,*
Simone de Beauvoir

*Women, Race & Class,*
Angela Davis

*Ain't I a Woman:
Black Women and Feminism,*
bell hooks

*La Sexuation du monde:
Réflexions sur l'émancipation,*
Geneviève Fraisse

*Les Guérillères*
Monique Wittig

While we were writing this book, there has been more than one occasion to protest in Paris. One of the most memorable events we remember was in response to Donald Trump's election to office, which made Parisians want to spring into action, take to the streets, express their views on social media and paint placards. Why? Because the new American President had been voted in despite his repeated attacks against women's rights. Around the same time, anti-abortion protests were organized in Paris. Some candidates for the 2017 French presidential election made worrying speeches regarding women's rights. And on 21 January that year, thousands of protestors set out from Trocadéro in Paris to show solidarity with the 'Women's March' in Washington on the same day. So what should you read and watch to sharpen your discourse and bring feminist values into your daily life?

**Newsletters to subscribe to:**

*Lenny*
*Les Glorieuses*
*Quoi de meuf?*

**Films to watch:**

*Mustang*
by Deniz Gamze Ergüven

*Divines*
by Houda Benyamina

*Summertime*
by Catherine Corsini

*Tomboy*
by Céline Sciamma

**Podcasts to listen to:**

*La Poudre*
*Stuff Mom Never Told You*
*The Guilty Feminist*
*Génération XX*

**Instagram accounts
to follow:**

@vscyberh
@payetashnek
@lallab
@causettelemag
@klairette

# On a barge in Neuilly
## with **Anna Reinhardt**

*A cape*
*A barge*
*A guitar*
*Swimming lessons*

Anna invites us on to her barge, which is moored to a dock on the
River Seine. Her barge isn't just a passing fad of some bourgeois
thrill seeker who's tired of living in an apartment in the ninth *arron-*
*dissement*. Anna grew up on this boat and on this stretch of the Seine.
She's now planning to move back here after several years of travel-
ling around.

Anna is a journalist and musician. She writes nostalgic lyrics to
the mystical, indie music tracks she composes for Hotel, the band
she's formed with her boyfriend. 'We chose this name because any-
thing can happen in a hotel, you can laugh, cry, lose yourself, make
love, dream, dance, sleep, alone or with someone else . . .' Anna has
the very Parisian trait of intellectualizing everything. She makes us
think of the philosophical Paris of the 1970s, when the wind of revo-
lution blew through the city, and key thinkers, researchers, artists
and activists hung out in cafés, burning with the desire to put things
right in the world through their words.

It's the middle of winter. The trees are bare on the banks of the
Seine. The river is grey. We can see the skyscrapers of La Défense
rising up on the opposite embankment; the forty-floor Tour France
tower block pierces the sky. We climb on to Anna's old blue barge,

which creaks and sways as we step foot on it for the first time, and we're enthralled by the peaceful and poetic atmosphere that seems to prevail here. She plays us one of her songs, called '*Ma Rivière*' ('My River'). 'It pays homage to this place and to my childhood. I wrote it after I lost my parents,' she tells us. 'When I'm feeling particularly sombre, I head towards the Seine, without even realizing where I'm going. The sea is contemplative. The river cleanses.'

Anna is wrapped up in a black, woollen Yves Saint Laurent cape that belonged to her mother, confessing, 'I spent my childhood hidden under this cape on the way to school.' This memory is just like she is: a blend of creativity, elegance and secrecy. And also very Parisian. 'My father was an academic and knew every little corner of the city. He'd hung out in all the bars with Jacques Brel and his band,' she remembers. 'My mother was a French lecturer and researcher at Paris-Sud university in Orsay. I have a very clear memory of their elation on the day socialist candidate François Mitterrand was elected as President. We were the only left-wing family in Neuilly! But when I organized a party at my place, I put everyone straight!' Her parents gave her an insatiable curiosity for other cultures and, above all, a love of music. Between them, they embodied the quintessential Parisian intellectual. 'I have an unbelievable amount of admiration for them. Thanks to therapy, I learnt to love them the same way I would love anyone else. I know where I come from and I understand my heritage.' Anna could have easily continued working as a journalist (she was a reporter on one of the most popular morning TV shows in France), but she's had to pull back so she can dedicate her time to music. Like her parents, she's driven to making choices that go against the grain.

After the near-revolutionary events of May 1968, a large number of people already living in Paris took advantage of a critical period for river transport to buy cut-price barges from the Netherlands and moor them to the riverbanks in the sixteenth *arrondissement* and

Neuilly-sur-Seine. And that's what Anna's parents did. 'Their barge was like a safe haven. There would always be an Argentinian refugee, a Japanese violinist, a whole community of artists and researchers permanently living there. They all had humanist values. The door was always open. That's what real life on a barge was like.'

That way of living freely, without constraints, applies to her love life, too. Anna got married a few years back, after the birth of her two children. There was 'a very beautiful party in my grandmother's house in the South of France'. Then, she divorced two years later, 'without the slightest regret'.

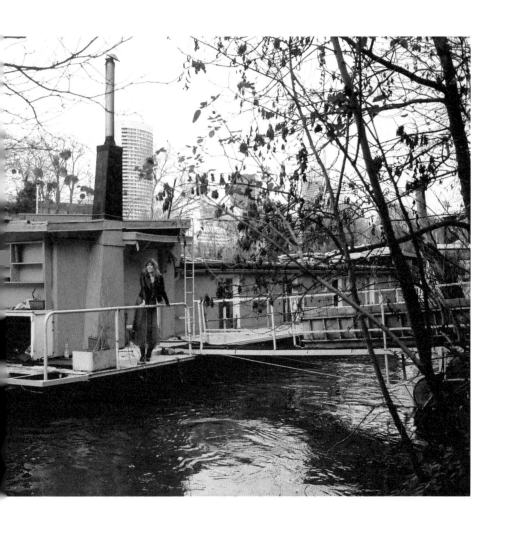

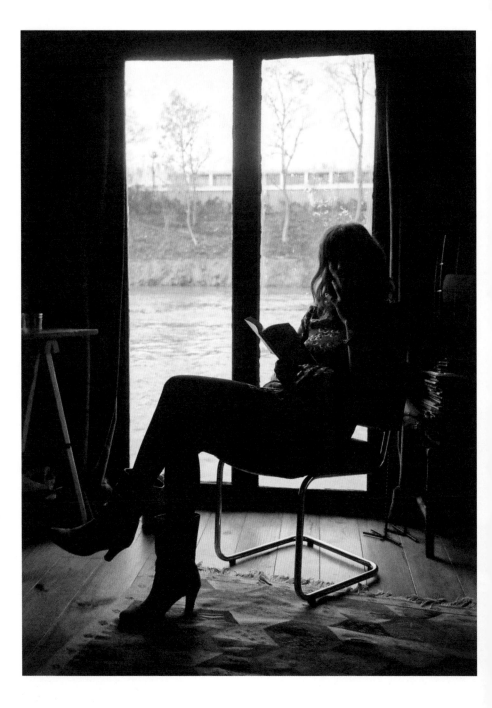

These days, she shares her life with a younger man whom she met at a Rolling Stones concert in Mogador, before forming the duo Hotel together. 'I gave him a guitar, he gave me lessons. We realized we had to create songs together. I no longer expect my partner to solve my personal problems. I'm now in the most intelligent relationship I've ever had with a man.' Again, there's her mild tendency to intellectualize everything.

Her barge is in the process of making a big comeback. In a few months' time, Anna will move back in here with her boyfriend and her two children, who are aged six and eight and a half. For the last few months, the children have been taking swimming lessons, for safety reasons. They're making the lounge bigger, refitting the kitchen. It's a funny old thing, restoring a barge. She's had to take it to a dockyard so they can redo the hull and then refloat it. 'The workmen all spoke to me about my father. They welcomed me in like a true boatman. I felt validated.' However, living on a barge does have its drawbacks. You need to sweep up the leaves, clean the deck. But there's a constant feeling of calm that cuts through the commotion and cars above as they zoom past the quays. 'I couldn't live on a barge in the centre of Paris,' she explains. 'There are people who gawk at you and blinding lights from tourist boats.'

In pride of place, just inside the entrance to the boat and opposite the wobbly pontoon you cross to access the vessel, there's a grand piano covered in a bit of dust. It belonged to her godfather, who was a famous musician. Anna sits down and plays a few chords. As she perches at the piano, wrapped in her cape, we can't help thinking that the bohemian Paris of the hippy 1970s is not completely lost.

# Our Paris.
## The summer uniform

A floral dress, sandals
and a straw bag.

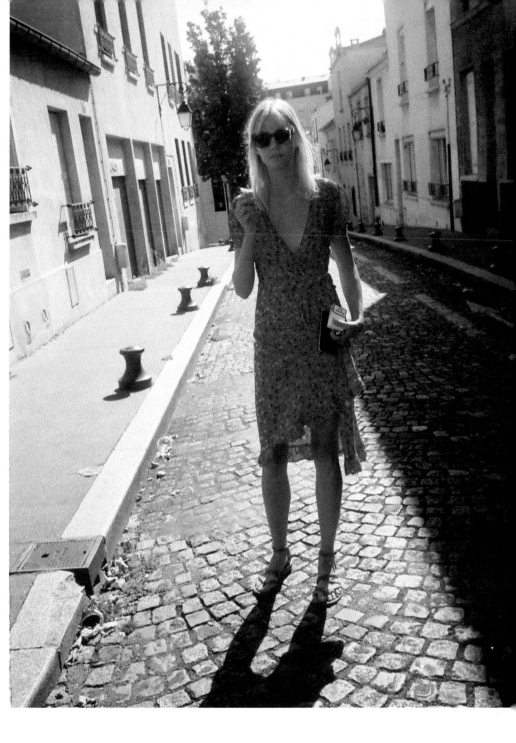

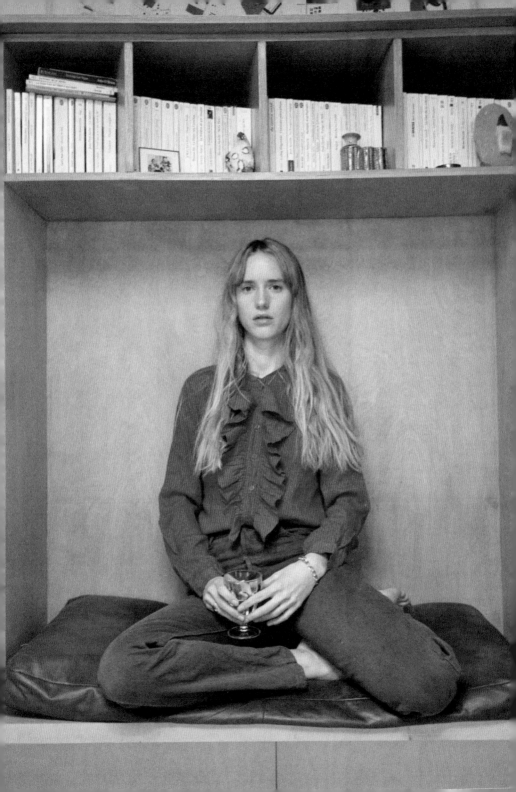

# In Saint-Germain-des-Prés
# with **Zoé Le Ber**

*A Persian rug*
*A frilly shirt*
*A sarong*
*Black coffee*

We're just a short walk away from the prestigious Sciences Po university and not far from boulevard Saint-Germain. Everything makes an impression on you in this Parisian *quartier*, whether it's the pretentious students smoking cigarettes on the pavement or the white cornicing on opulent-looking buildings with generous cobblestone courtyards. To get to Zoé's place, we have to cross one of those courtyards, where you can still hear the faint echo of horses' hooves, before climbing an external stone staircase leading to a tall glazed door. Then, we climb another two floors of a huge stone staircase embellished with a red carpet, beneath a soft glow from wrought-iron lights that look as though they've adorned the walls for several centuries.

As soon as we cross the threshold of Zoé's apartment, we leave the old, opulent Paris behind and enter a place steeped in worldly travels. Seashells line the edges of a huge bookcase where Emily Brontë rubs shoulders with Gabriel García Márquez. There's a Persian rug, a Moroccan pouffe and African fabrics decorating the armchairs. Zoé Le Ber is a photographer, filmmaker and massive globetrotter. She gallivants across the world and returns with fascinating, foreign and sometimes disturbing images.

Her work is admired across a number of industries and she

regularly films commercials for fashion brands, directs music videos and makes documentaries, the latest of which will be broadcast on the news channel Vice. It's a very poignant film inspired by several months spent with migrants on the island of Kos. Many were Afghans fleeing the war and hoping to cross the Balkans to reach Western Europe.

Zoé's taste for travelling overseas comes from her childhood. 'My parents are Parisian, but I have Russian, Italian and English roots,' she begins. 'Both my parents decided to leave Paris when I was small. I grew up on Porquerolles island as well as in Brittany, and also in Marseille. The sea was never far away. When you have skylines like those as a child, possibilities in life seem endless. Borders never existed for me.' Her pale beauty and long blonde hair contrast with her bold personal style. Today, she's wearing a frilly fuchsia shirt and brown trousers. You only need to take a look at her Instagram feed to see that her notion of style is very different to the stereotypical Parisienne. There are pictures of her in a fluffy leopard-print jacket or wearing a turban round her head. 'I choose subjects for my films that mean I can travel far away. I'm always researching elsewhere. Taking myself somewhere else helps me to be creative.'

When we ask her about her childhood and education, Zoé's a little vague. It seems as though her past has its share of secrets, scars maybe. We simply know that she roamed the world with her two parents and that after a degree in law and political science, she acted in a number of films before gravitating towards directing. 'I learnt the profession by myself, by watching shoots and reading lots of books about it, like *The Anatomy of Story* by John Truby.' Zoé makes us both a green tea in her open-plan kitchen where she loves rustling up simple dishes for her group of friends who all come from the world of film. But what she really wants to communicate to us today is her thirst for travel. 'I've just come back from a road trip in Morocco. I was on holiday, travelling between Marrakech and Zagora.' She tells

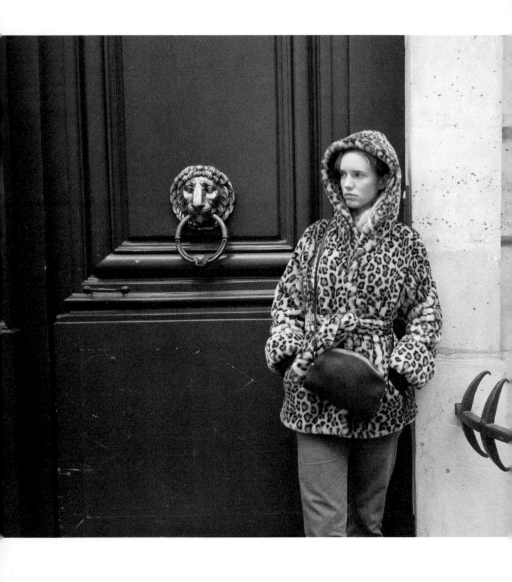

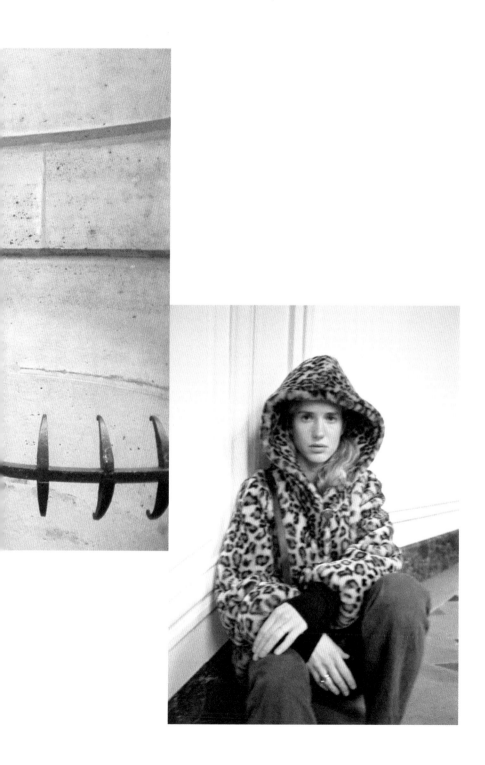

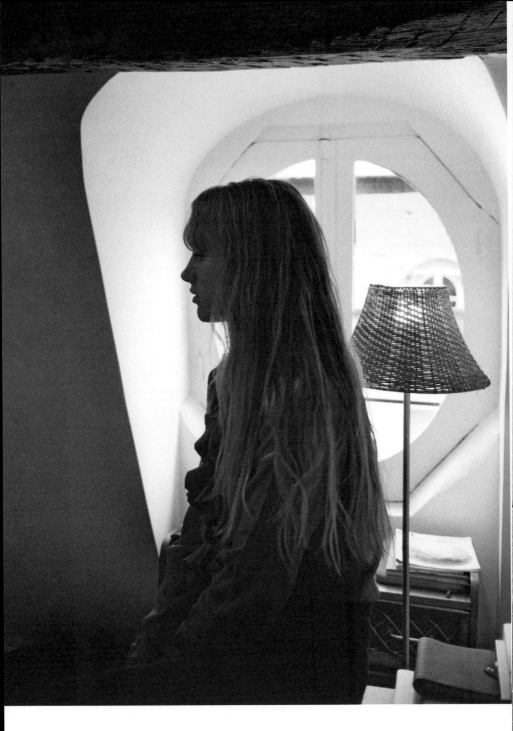

us about the Drâa valley, Taroudant, Essaouira, the beautiful landscape and the sun setting over the desert.

Zoé prefers to travel alone. 'I immerse myself in the country I'm visiting, dress like the people who live there, lose my way in the backstreets, speak to locals in cafés, get their advice, ask them where their favourite places are. I leave here with a suitcase that's practically empty, and buy fabrics at markets. I love throwing together a sarong or tying a scarf round my head. I'm a bit of a chameleon, that's my mindset anyway.' She applied the same philosophy when travelling in Iceland: 'I felt as though I was on another planet'; Ghana: 'Africa reminds me of my childhood and the trips I used to take with my father to Lamu in Kenya'; Madagascar: 'a madly intense, month-long trip, cut off from the rest of the world'. Each time she goes, she returns to Paris laden with fabrics, images and unusual objects that she scatters around her top-floor apartment.

Zoé is sometimes scathing about the Parisian microcosm, as many Parisians are. 'Paris fascinates me, but it's easy to criticize: people have a tendency to isolate themselves.' However, a few minutes later she smiles, admitting, 'When I return from my travels, nothing makes me happier than going back to my little café. I love drinking a ristretto at the bar in Le Comptoir des Saints-Pères. I pick up scraps of conversation.' Only in Paris do the locals behave like travellers.

# Our Paris.
## The winter uniform

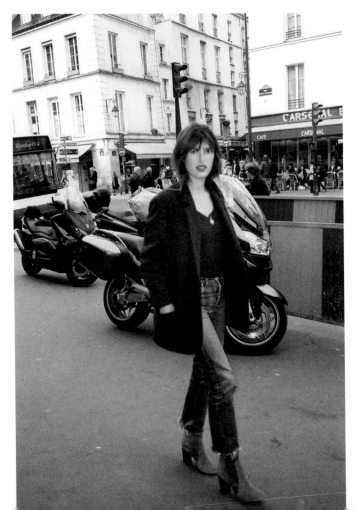

A man's jacket or a blazer, cashmere sweater, straight-cut jeans and boots.

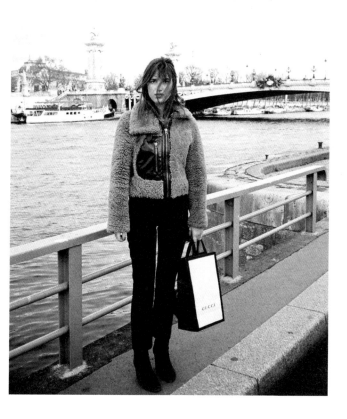

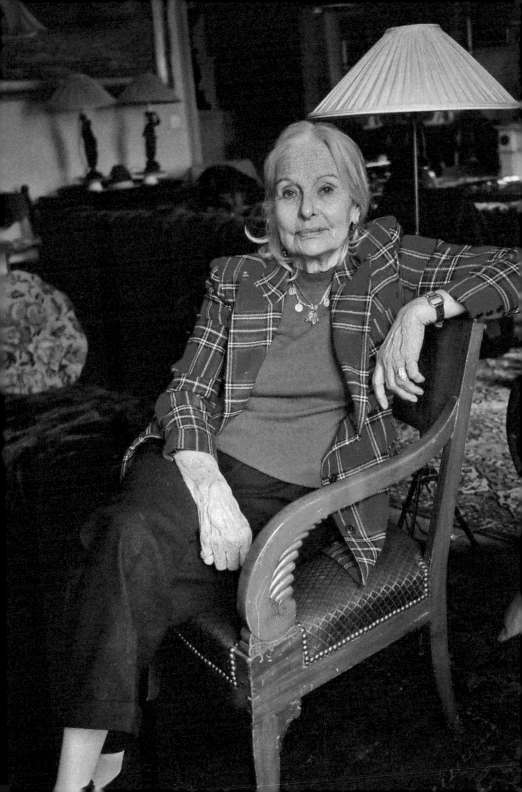

# Rue du Bac
## *with* **Françoise Golovanoff**

*A Hermès bag*
*Henri IV*
*Brigitte Bardot*
*'Godasses'*

When we started researching women for this book, we were absolutely certain that we had to include a portrait of the kind of white-haired, regal Parisienne that we see every day on the streets of Paris. We were hoping to find an older lady wearing a pearl necklace, one who could have come straight out of a Sempé cartoon, a grandmother whom you wouldn't be surprised to find sitting on a bench in the Jardin du Luxembourg, keeping an eye on her fox terrier while reading a slightly subversive political essay.

Our criteria were so specific that they seemed almost impossible to fulfil. Until, one day, Jeanne was scrolling through Instagram and came across Françoise with her azure-blue eyes. She is just as astoundingly beautiful as her daughter, fashion journalist Alexandra Golovanoff, another iconic Frenchwoman. Françoise is the very last woman we met for this book, almost a year after our grand tour began. She lives in the seventh *arrondissement*, not far from rue du Bac, and when we enter her apartment, the interior makes quite an impression on us. It's filled with objects and furniture from the neo-classical era, and the place smells of the wax you use to polish wood. This makes sense as Françoise and her husband are antiques dealers. The shop they've managed for many years is just a short walk from

here, in an area that's well known to those who love the very Parisian pastime of hunting for second-hand goods, pre-loved objects, vintage items steeped in history. On rue de Beaune, there are dozens of antiques shops, and the wealthy will often go there to find a chandelier, rug, piece of furniture or art to give their home interior a Parisian feel. During our interview, Françoise's husband, André, who was previously a doctor, watches over her from afar, but not too much.

'I was born during the war, in Pau, the city where Henri IV was born,' she begins. 'My family was Parisian but had fled the capital during the Occupation. After the war, we returned, and I still have photos of me learning to walk in Trocadéro when I was about one.' That's a real Parisienne for you. The capital has been so deeply ingrained in Françoise for so long that the story of her life is, in itself, a history of the city. Her story started in the vast sixteenth *arrondissement* that stretches from the Eiffel Tower to the far side of the Bois de Boulogne, and is known for accommodating some of the wealthiest families in Paris. She grew up there and continued to live there until around fifteen years ago. 'It was a lot more diverse at that time. You'd find people from all social classes in the same building. These days, you only ever bump into perky young professionals,' she says, smiling. 'I really enjoyed raising my three daughters there. We used to live close to Ranelagh. They would go to school on rue de la Pompe and at weekends we would walk to the Bois de Boulogne. Every day I would take the number sixty-three bus to go to work at our shop on rue de Beaune, not far from here. It's a beautiful journey from Austerlitz to La Muette! We spent some time living in Moscow, but Paris is the only place that still enthrals me. I enjoy everything, even the chaos. I don't know why people complain about it.' She loves going for strolls, crossing the Seine to take her dog for a walk in the Tuileries Garden and sauntering over to BHV, a luxury department store on rue de Rivoli. 'The walk is marvellous. I also like to be in the Sentier *quartier* at nine in the morning. There's so much diversity

here. I can't imagine living anywhere else. Although I don't always make the most of it, the mere fact that it's there is enough for me.'

We're dying to hear her talk about her teenage years, so we can find out what Paris was like in the 1960s. 'I didn't really go to clubs. It was more fashionable to go to parties or to Le Drugstore on the Champs-Élysées where I would drink sodas in the afternoon.'

She looks at André when we ask her what style of clothing she wore back then. 'Brigitte Bardot style,' he asserts confidently. She shrugs, not quite in agreement. She acknowledges that she did wear her hair in a luxuriant bun like Brigitte Bardot, but points out that

she was rather more fascinated by beautiful American stars such as Ava Gardner and Olivia de Havilland. 'I studied in the Faculty of Arts at the Sorbonne,' she recalls. 'Girls were very smart back then. We wore gloves, high heels and silk scarves round our necks to go to class.'

Then Françoise makes a statement you could only ever hear in Paris: 'I'm interested in clothes, but not really in fashion.' We ask her to expand. Basically, she never goes shopping; her dressing room is full of clothes she buys randomly, on impulse, when she's out walking, dawdling past shop windows. And most items come from second-hand shops. 'Near our country house in Berry, there's a charity clothing shop where I often find fantastic things at low prices. I bought the jacket I'm wearing fifteen years ago. It was all moth-eaten, but I mended it.' Françoise knows how to sew, 'but not how to cut a pattern', she clarifies. She embroiders, she knits (her daughter Alexandra revealed she would never have launched her line of cashmere sweaters without the expert eye of her *maman*), but will only modestly admit to 'knowing how to cobble something together'. Françoise refers to 'my countryside' when speaking about her secondary residence. She travels there by car every weekend as her dog hates the train. 'Once you get to forty-five or fifty years old, you suddenly want to have your own garden. You'll see!' she teases gently. Françoise uses an old-fashioned slang term for shoes, '*godasses*', and the word is impossibly chic on her lips, which happen to be painted the same subtle shade of pearly pink as her antique stud earrings.

Nowadays, she's grandmother to nine grandchildren aged between four and seventeen years old. Sometimes in the summer, she looks after all nine of them at the same time. They come and stay at her country house, she takes them to play tennis and organizes little painting or *pâtisserie* workshops for them. 'It felt a bit strange when I had my first grandchild. There was a baby, but it wasn't mine. Since then, I've got used to it. I have a good laugh with them.'

# Our Paris.
## Dining out

Jeanne has been a foodie from birth, so here's a
selection of her favourite Parisian restaurants.

*Le Servan,*
where everything is good,
from the bread to the wine.
32 rue Saint-Maur, 75011

*Le Clown Bar,*
for natural wine and gourmet
tapas. 114 rue Amelot, 75011

*La pointe du Grouin,*
for casual dining and drinks. The
only place in Paris where you pay
in the restaurant's own currency:
grouins (meaning 'snouts').
8 rue de Belzunce, 75010

*Le Petit Marché,*
for its tuna millefeuille in
summer and caramelized
duck breast in winter.
9 rue Béarn, 75003

*Chez Philou,*
Jeanne's father's restaurant,
so you may see her there.
12 avenue Richerand, 75010

*Le Comptoir,*
the best food in Paris, according
to the expert, Jeanne.
59 carrefour de l'Odéon, 75006

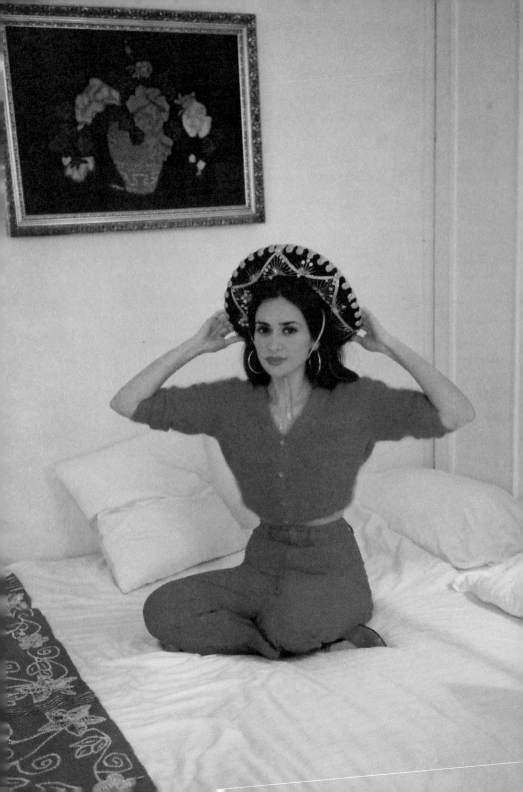

# In Montmartre
## with Lamia Lagha

*The New Wave*
*Red trousers*
*Alfred de Musset*
*The overground métro*

Lamia has lived in Paris for seven and a half years. Her little studio apartment is nestled on one of the sloping streets of Montmartre. Every day, tourist coaches flock to this spot, visitors eager to view the vintage Paris of Amélie Poulain. Lamia is mad about her *quartier*. 'I like its village feel,' she says with a smile. 'Sometimes at night, I go for a walk on my own. If I turn left, I end up in the red-light district in Pigalle, surrounded by sex shops and prostitutes. Two streets on from that is a more affluent Paris with delicatessens and heated outdoor bars.'

Lamia is a stylist. She's worked for some of the major Parisian fashion houses such as Jean-Charles de Castelbajac. She now has a key role at Jacquemus, a young label owned by Simon Porte Jacquemus, one of Jeanne's very close friends. Lamia's willowy figure and the way she creates such insanely elegant outfits made Jeanne fall in love with her style. Even today, dressed head to toe in red, she looks like a 1950s fashion model. She's radiant. She could almost make us forget that it's drizzling on the other side of the window and that the Paris sky has turned the greyish shade typical of short February days.

Like many people who've moved to Paris as adults, Lamia dreamt of the capital long before she settled here. She was born in Dortmund in Germany, but spent a large part of her life in Berlin. Her parents are Tunisian. 'I always felt as though I was torn between two worlds. In Tunisia, I was German, and in Germany, I was Tunisian. At home, I soaked up the culture of my country of origin. My father always encouraged me. He said, 'The world is all yours! You can do anything.' He gave me what I believe is a typically Arab sense of pride. But I also feel very Germanic. Berlin is my favourite city. Especially in summer.' Her fascination with Paris dates back to her childhood, when she was already obsessed with clothes. She dreamt of a career in fashion and was passionate about 1950s culture. 'I binged on New Wave films, Jacques Tati, Jean-Luc Godard. I daydreamed about Frenchwomen from that period. The way they dressed, so simple and stylish. The way they spoke too. I felt an unbelievable pull towards this romantic, nostalgic thing that only seemed to exist in Paris.' She first visited the city on a school trip when she was seventeen. She remembers falling madly in love with it as if it were yesterday. 'It was pouring it down, worse than today, but I was in awe. The lights, the buildings with their Haussmannian architecture, the French language I could hear everywhere I went. I felt as though the images, the sounds, were drawing me in, and I knew that one day I'd come and live here.'

After studying at a fashion design school in Düsseldorf, Lamia decided to spread her wings. She was twenty-two. She knew no one in Paris, but one of her friends had just spent a year as an au pair with a Parisian family in the east of the city, and she passed their details on to Lamia. She looked after their children in exchange for accommodation.

She was desperate to find an internship, and her plan was to learn to speak French as soon as possible. As she continues her story, Lamia leans over and pulls a paperback from the little shelf above

her sofa. It's a dog-eared copy of *On ne badine pas avec l'amour* (*No Trifling with Love*) by Alfred de Musset; by immersing herself in the pages of this book, she was able to learn the language.

Her Parisian life took a new turn when she landed a job in an American Apparel store, and was finally able to quit her job as an au pair.

'All of a sudden, everything changed,' she declares. 'I'd been completely alone, then the next day I was invited to loads of parties, I met the entire Parisian fashion world in just a few months. Paris is really

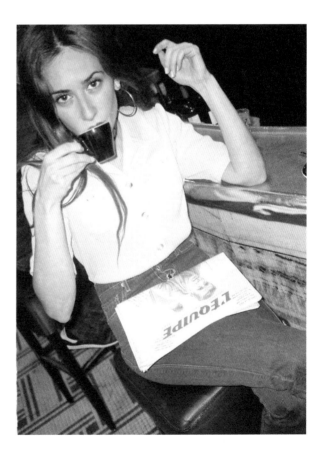

funny like that. One day you're all alone in a huge city, and the next, you feel as if you have the whole world in your hands.' Then it all took off for Lamia, who ended up landing an internship with the designer Kris Van Assche.

So, does she feel genuinely Parisian now? 'I always answer that question by saying I'm a citizen of the world. Of course, these days France is my home, but it's complicated here when you're Muslim. I'm constantly berated for the attacks. It's as though I have to express an opinion, have to justify myself. I find that really sad.' She has a very lucid perspective on the capital, due to all the injustice she sees. She feels overwhelmed by the bleak lives of so many migrants sleeping beneath the overground métro track, just a few metres from here, and is shocked by the inequality that exists between the centre of Paris and its *banlieue*. 'I help out a lot. I volunteer for organizations involved in supporting refugees and helping the homeless. And I volunteer at a youth centre in Seine-Saint-Denis. I would like to do more, but whenever you want to do something here, there's tons of paperwork to fill in. That's definitely not the case in Berlin!' As for Parisiennes, they continue to intrigue her. 'There's always a hint of melancholy deep within their eyes. At the start, I couldn't understand why no one replied to me when I arrived somewhere and called out "hello". I thought Parisians were snooty. Now I know that's just a front. I've had some difficult experiences in Paris, but I've also found people willing to help me along the way.'

# Our Paris.
## City secrets

Here we've listed twenty unusual, secret or romantic places in the capital, one for each *arrondissement*, so you won't miss a thing in Paris.

I. *La librairie Galignani*, for its impressive, high-quality collection and the lovely smell of its wooden floor. 224 rue de Rivoli

II. *La Comédie-Française*, and its little ticket office where you can buy five-euro seats an hour before the show. 1 place Colette

III. *Le Centre culturel suédois*, where you can snack on a marinated salmon sandwich in the centre's historic cobblestone courtyard. 11 rue Payenne

IV. *Le square Barye*, on the tip of île Saint-Louis, for a romantic siesta beneath the weeping willows. 2 bd Henri IV

V. *La piscine Pontoise*, for the simple pleasure of getting changed in one of their private cubicles overlooking the pool. 19 rue de Pontoise

VI. *La place de Fürstenberg*, to watch the street lamps light up as night falls over the pink paulownia trees in spring. Rue de Fürstenberg

VII. *Le musée Rodin*, to read a book on a bench in the museum garden. 79 rue de Varenne

VIII. *La maison LOO*, so you can marvel at a pagoda built right in the middle of Haussmannian Paris. It was constructed at the start of the century for an art dealer who was in love with China. 48 rue de Courcelles

IX. *Le musée de la Vie romantique*, to admire George Sand's jewellery or lounge around in the garden. 16 rue Chaptal

X. *Le passage Brady*, to enjoy a curry and buy incense or jasmine rice in the labyrinth of shops. 46 rue du Faubourg-Saint-Denis

xi. *Le Perchoir*, where you can sip on a glass of wine while gazing out over the whole city. 14 rue Crespin-du-Gast

xii. *La coulée verte*, for a traffic-free stroll towards Passarelle Simone de Beauvoir, the newest bridge in Paris.

xiii. *Le quartier de la Butte-aux-Cailles*, which, for a second, will make you think you're in a country village as you wander down the sixteenth-century rue des Cinq-Diamants.

xiv. *La galerie Camera Obscura*, for its collection of fine-art photography including the works of Sarah Moon, Willy Ronis and Marc Riboud. 268 bd Raspail

xv. *Le tennis de la Cavalerie*, where you can hit a few balls on the fifteenth floor of an art deco building with a view of the Eiffel Tower. 6–8 rue de la Cavalerie

xvi. *Le jardin du Panthéon bouddhique du Musée Guimet*, to discover the 250 Japanese works of art in this peaceful haven. 19 avenue d'Iéna

xvii. *Le marché Poncelet*, a market where you'll find a crazy selection of cold meats, insane cheeses and delirious pâtisseries. Open every day. Rue Poncelet/ rue Bayen

xviii. *La Recyclerie*, to wolf down an eco-friendly vegan brunch in a decommissioned railway station. 83 bd Ornano

xix. *La butte Bergeyre*, where you can lose yourself in the little backstreets of this small hill in Buttes-Chaumont, home to one of Paris's four vineyards.

xx. *La rue Piat*, for the most beautiful view of Paris from Belvédère de Belleville square.

SEINE

Neuilly-sur-
Seine

Place Pereire

Pa...
Tu...

PÉRIPHÉRIQUE

Rue

Saint-Germain-

SEINE

nt-Ouen

Montmartre

Gare de
L'Est

Faubourg-
Saint-Martin

Belleville

JESUS PARADIS

Canal
Saint-Martin

Ménilmontant

Village Popincourt

CAFÉ AUX DEUX AMIS

Boulevard Voltaire

Notre-Dame

Rue de Lappe

EARE & CO.

Île
Saint-
Louis

Le Square
Trousseau

JARDIN
LUXEMBOURG

SEINE

PÉRIPHÉRIQUE

Quartier Chinois

# *Thank you*

To Amélie, Nathalie, Patricia, Charlotte, Fanny, Sophie, Jesus, Noemi, Valentine, Emily, Dora, Lola, Dorine, Sylvia, Crystal, Lucie, Anna, Zoé, Françoise and Lamia for agreeing to be the Parisiennes featured in our book. We're very proud to have you as part of our team.

To Michaëla Thomsen, Alexandre Guirkinger, Soko, Saskia Gruyaert, Marieke Gruyaert, Jessica Piersanti, Jean Picon, Jordan Henrion, Sabina Socol, Octave Marsal, Simon Porte Jacquemus, Balthazar Petrus, Eléonore Toulin, Florence Tétier, Claire Margueritte, Chloé Dupuy, Emanuele Fontanesi, Valentina Moreno and Nino, Alice Aufray and Arthur, Inès Mélia, Agnete Havgaard Christensen, Louise Damas, Lila Cardona, Lola Palmer, Mona Walravens and Pierre-Louis Leclercq for their various enthusiastic contributions to this piece of work.

To Chloé Deschamps, our beloved editor, who never really left our side throughout this grand tour of Paris. To Matthieu Rocolle for a design that reflects who we are. To Nina Koltchitskaia for accompanying us on our travels, camera in hand. To Jürgen Lehrer for his kind and generous advice.

To café Aux Deux Amis, Café de Flore and Hôtel des Saints-Pères for hosting our work meetings.

To Pascale Damas and Brigitte Bastide, our *mamans* and favourite Parisiennes.

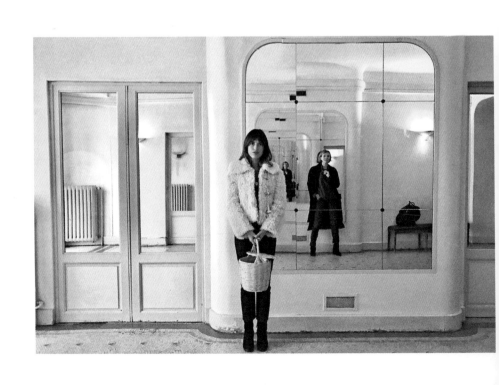